THE GIBSON GIRL AND HER AMERICA

THE BEST DRAWINGS OF CHARLES DANA GIBSON

Selected by
EDMUND VINCENT GILLON, JR.

With an Introductory Essay by
HENRY C. PITZ
Former Director of Illustration,
Philadelphia College of Art

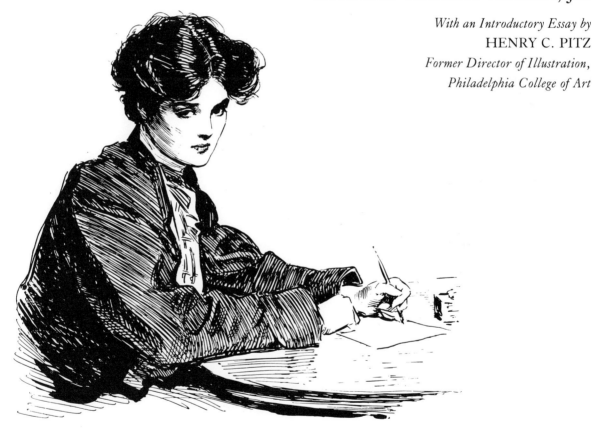

DOVER PUBLICATIONS, INC., NEW YORK

Copyright © 1969 by Dover Publications, Inc.

All rights reserved under Pan American and International Copyright Conventions.

Published in Canada by General Publishing Company, Ltd., 30 Lesmill Road, Don Mills, Toronto, Ontario.

Published in the United Kingdom by Constable and Company, Ltd., 10 Orange Street, London WC2H 7EG.

The Gibson Girl and Her America is a new selection of Gibson drawings, first published by Dover Publications, Inc., in 1969. The pictures were selected and the book designed by Edmund Vincent Gillon, Jr. The introductory essay, "Charles Dana Gibson, Delineator of an Age," was written specially for this volume by Henry C. Pitz. The illustrations (except those in the introductory essay) are reproduced from the following volumes:

Drawings by Charles Dana Gibson, R. H. Russell & Son, New York, 1894.

London as Seen by Charles Dana Gibson, Charles Scribner's Sons, New York, 1897.

Sketches and Cartoons by Charles Dana Gibson, R. H. Russell, New York, 1898.

The Education of Mr. Pipp, By Charles Dana Gibson, R. H. Russell, Publisher, New York, 1899.

A Widow and Her Friends, Drawn by Charles Dana Gibson, R. H. Russell, New York, 1905 (originally published 1901).

The Social Ladder, Drawings by Charles Dana Gibson, R. H. Russell, New York, 1902.

Our Neighbors, By Charles Dana Gibson, Charles Scribner's Sons, New York, 1905.

The Gibson Book: A Collection of the Published Works of Charles Dana Gibson, Charles Scribner's Sons, New York, two volumes, 1906 and 1907.

International Standard Book Number: 0-486-21986-0
Library of Congress Catalog Card Number: 68-28065

Manufactured in the United States of America
Dover Publications, Inc., 31 East 2nd Street, Mineola, N.Y. 11501

CONTENTS

CHARLES DANA GIBSON, DELINEATOR OF AN AGE
By Henry C. Pitz *Page vii*

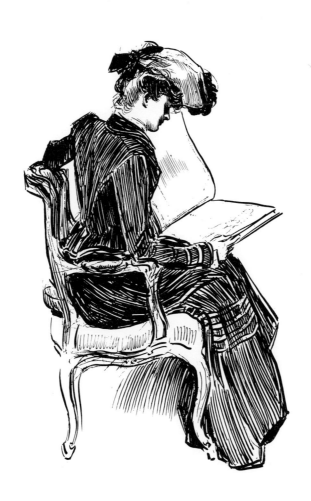

CHARLES DANA GIBSON
DELINEATOR OF AN AGE

Henry C. Pitz

THE effect of an artist upon his contemporaries is usually a subterranean and elusive thing, seldom plain to all eyes. And seldom does such a force touch more than a fraction of its potential audience. When it reaches up and down through social layers and commands imitation, when it influences the habits, demeanor and external appearance of large numbers and leaves its imprint on two decades of bustling life, it acquires the nature of a pictorial marvel. It becomes an important page in social history, a revealing portrait of an age, a fascinating treasury of mass psychology. And that all this should come out of an ink bottle!

Behind the ink bottle was a man, of course—a dedicated, hard-working artist of conspicuous talent who in his younger days could never have suspected the power hidden in a dashing pen technique. No one could have been more astonished than Charles Dana Gibson himself to witness his art in the process of shaping life, to watch a large portion of the American populace trying to conform to the people in his pictures.

Mimicry on a national scale is not a new feature in American life. The strong persuasions exerted today by the motion picture, theater and television were once wielded by the illustrator. But such widespread power over a period of about two decades can seldom be traced back to a single personality. Gibson became America's conspicuous example of an artist intuitively absorbing the yearnings of his time and crystallizing them into captivating pictorial images. There was a time when his pictures were known in practically every home in the land. The latest copies of the comic magazine *Life* were opened first to the Gibson pages. The large horizontal Gibson albums, packed with his pictures, were on countless parlor tables, and on the walls were large size reproductions of his most beloved subjects. Gibson reproductions crept from the printed page onto all kinds of likely and unlikely surfaces: china plates and saucers, tiles, souvenir spoons, tablecloths, pillow covers, chair covers, ashtrays, matchboxes, screens, fans and umbrella stands. A pet hobby of the time, pyrography, encouraged thousands to scorch Gibson types onto acres of leather strips and wooden panels. There was a Gibson wallpaper designed for bachelors' rooms, and his drawings of girls' heads were traced onto handkerchiefs and embroidered.

All these are the amusing and fascinating artifacts of a vanished age which has begun to arouse our curiosity, and they are becoming collector's items. But it is well to remember that the Gibson craze was recorded not merely in the form of a heterogeneous collection

of odd objects but in the acts and impulses of living people. The phenomenon of a large portion of a great nation following the persuasions of an ink line is not to be summed up in an amused and indulgent smile; it is a matter for some pages from the social historian, who is all too prone to ignore the historical importance of pictorial documentation.

The creator of that vitalizing ink line was a modest and thoroughly honest man who used his talent to express his most earnest convictions. His outer appearance—Gibson was tall, distinguished and urbane—was reflected in his pictures. His inner life, direct and uncomplicated, was in them, too. He was not a consciously deep prober, but many of the surface features to which he was sensitive had deep and mysterious roots. He had a lot to reveal about the character of his era and had more than a little to do with the shaping of it.

Gibson's life was not the tangle of rebellions and frustrations that has come to be associated with artists. He had his share of griefs and misfortunes, which he met with simple courage and acceptance. Gibson was born on September 14, 1867, into a happy family of very modest means. His father was Charles DeWolf Gibson, a Civil War lieutenant, his mother Josephine Elizabeth Lovett, a lively, spontaneous and warm-hearted young woman. Both had behind them an almost unbroken chain of New England ancestors, stretching back to the early settlers. Young Charles had an older brother and three younger sisters. He grew up in an atmosphere of affection and encouragement.

If we make the usual search for ancestral talent, we find a great-grandfather who was a painter of miniatures in Boston; Charles Dana's own father also drew in an amusing, amateur way. The boy showed his inclinations early. His first instrument was neither pencil nor brush but scissors. From the time of an early illness during which his father amused him by cutting some animal shapes from paper scraps, young Gibson developed an uncanny knack for scissoring delightful and expressive shapes from paper, a wide range of human figures, birds, fish, quadrupeds, trees and other natural forms. These were not mere clumsy, childish efforts; they were adroit, humorous and charming, and showed an innate appreciation of silhouette shapes (Figure 1). When, at the age of thirteen, Gibson was taken to display his cut-out skill before the noted architect George B. Post and the sculptor Augustus Saint-Gaudens, his deftness and spontaneous design impressed them.

When Charles was of high-school age, the family was living in Flushing, Long Island, and the boy's talent was so apparent that he took the entrance examination for admittance to the Art Students League and passed it. At the time the League was one of the best art schools in the country, with a faculty that included Thomas Eakins, William Sartain, Kenyon Cox, William Merritt Chase, Walter Shirlaw, Edwin Blashfield and J. Alden Weir, among others. Gibson spent two hard-working years in this stimulating atmosphere. Talk at the school was largely of the growing reputations of so many of its recent graduates in the fields of painting and illustration. Most students were laboring to build up portfolios of impressive samples and preparing to confront the strange world of the gallery owner, the art editor and the publisher.

Young Gibson's hopes and almost empty pocketbook drove him in the same direction, but his ambition was ahead of his accomplishment. His drawings were labored and unprofessional, and he received little encouragement from the editors. However, he was tenacious and determined. He quit art school, lived at home and struggled to improve

his drawing. At last, in the winter of 1886 he sold a small drawing to the newly established, spirited magazine *Life* for four dollars (Figure 2). This was the most modest beginning of what was to become a lifelong association. Small as it was it cheered him on. He began to pick up other small commissions, and when, some months later, he sold a second drawing to *Life* he felt he was on the border of professionalism. There was a noticeable improvement in his work, and presently he took the plunge of opening a studio in New York. Gradually he was making his way.

The pen began to fascinate him more and more. Every month he studied in the pages of the magazines the drawings of the brilliant company of American artists that was making American illustration noted throughout the world. Edwin Austin Abbey was one of his early idols, along with Arthur B. Frost, Howard Pyle, E. W. Kemble, W. T. Smedley, C. S. Reinhart, Palmer Cox and Albert Sterner. Frederic Remington, a fellow student at the League, was beginning to attract attention. The dean of American illustrators, Felix Octavius Darley, active to the end, died in 1888, the year in which young Gibson began to feel established.

The close study of other artists' work greatly helped Gibson's own, and when he enlarged his awareness to include many European artists, he was able to educate himself in the best graphic art of the day. He came to know the work of the two founding fathers of modern pen technique, the Paris-centered Spaniard Daniel Vierge and the German Adolf Menzel. The British school appealed to him particularly and he collected clippings of the work of George Cruikshank, John Leech and Charles Keene and the early illustrative work of the Pre-Raphaelites. He had a special admiration for George du Maurier, whose figures had an elegance and upper-class suavity which in a short time Gibson was able to translate into his own—American—terms.

Meanwhile, Gibson's technique was becoming broader and more flexible (Figure 3) and was moving rapidly toward the electrifying verve of his mature years. The times were ripe for it. Not only was Gibson able to profit by the brilliant examples of his predecessors, but he came along at the precise moment when the illustrator was being freed from his bondage to the wood engraver. The newer process of photomechanical engraving was now producing dependable facsimiles of pen drawings. No longer were there the anxious doubts about what the wood engraver would do to an original drawing; the photoengraving could capture swing and dash and a rollicking line. Gibson became interested in the work of the English draftsman Phil May, who had developed a very economical pen style, striving for a technique that expressed his ideas in the fewest possible lines. Gibson learned to use a longer stroke, working from the shoulder and elbow rather than merely from the wrist. But he was not satisfied with May's constant reliance upon outline and his spare use of modeling and dark tonalities. Gibson indulged his own need for rich darks and full-bodied expression, and soon moved into a scintillating technique that was unique in the world of pen and ink.

The world fell in love with that galvanizing technique. Gibson was acclaimed by fellow artist and layman alike, in both America and Europe. Soon he was the most imitated artist of his time. There were battalions of hopeful Charles Dana Gibsons, most of them mediocre or worse. A few, like Howard Chandler Christy and James Montgomery Flagg, fed upon the Gibson technique, but contributed something of their own to the style. Many other competent pen artists felt the Gibson persuasion, but incorporated it into their own independent expressions.

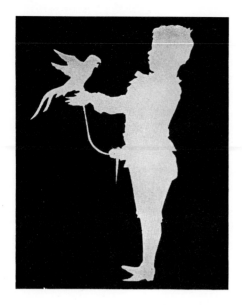

FIG. 1: It is interesting to make a quick appraisal of Gibson's artistic development in four stages. The small boy of five or six who cut the remarkable paper silhouettes of figures was exhibiting amazing skill with his fingers and proving that his sense of observation was unusually acute.

FIG. 2: If we jump ahead to the first published drawing of the youth of nineteen, we have a feeling that our expectations have been disappointed. The pen drawing of the chained dog might have been executed by hundreds of American youths of the same age. The pen technique is labored, routine and without confidence.

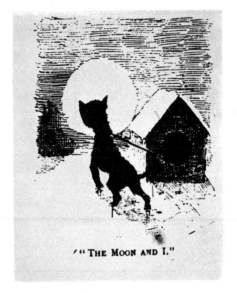

"THE MOON AND I."

FIG. 3: But how rapidly confidence and skill take command. Only two or three years later, the drawing of the two men at the table (Henry C. Pitz collection) shows the beginnings of authority. The figures are well drawn; the tones of dark clothing, white tablecloth and varnished chairs are well stated. Only a few years after this drawing, Gibson's technique reaches the masterly level—the fourth stage—which is abundantly evident in the collection in this book.

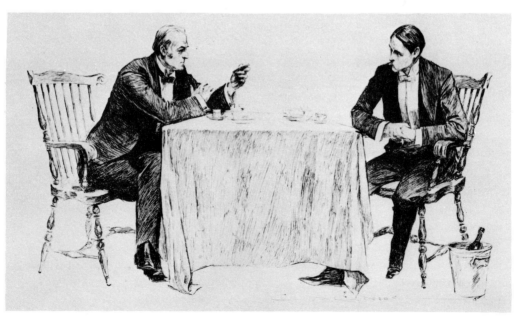

Gibson created many appealing types, but towering above all were the "Gibson Girl" and the "Gibson Man," particularly the former. These two types were a handsome, youthful pair, incredibly competent and assured. They could smile, but seldom laughed. They moved through a world that did not seem too demanding. Courteous, secure and serene, they had an Anglo-Saxon attractiveness which seemed to conquer all possible problems. They wore their fashionable clothes with unselfconsciousness distinction; their gestures were patrician. Yet they did not seem remote—not *too* remote. For a rapidly expanding middle class, busily climbing up the social ladder, here was a model of what they could hope to reach. A gifted artist, instinctively in tune with his time, was presenting the panorama of an American dream which he, too, believed in with all his heart.

The followers of that dream numbered millions. The younger women, in particular, tried to model their clothes, their gestures, their hair and features on the Gibson specifications. His pictures carried a message of hope, a tantalizing reach for a superior life. It was a dream that could not last, at least in that form. It was dissipated by the explosion of World War I.

Gibson threw all his pictorial energy into patriotic propaganda, but at the end of those four long years the world was a different place. His special world had vanished. His skill remained but he could not read the secrets of a disillusioned era. He continued to illustrate, then took on the burdens of editing *Life*, and in his later years retired to his island home in Penobscot Bay and painted—and painted well. But his touch with a vast audience was gone.

We can now see his pictures as part of our inheritance. They are honest pictures. The man himself is in them with his integrity, his lovable dignity and his warmhearted optimism. His time is in them, too. We can leaf through the pages of his albums and gain a more immediate understanding of that gilded age than could be derived from volumes of text.

HENRY C. PITZ

Plymouth Meeting, Pa.
August 1968

THE GIBSON GIRL AND
HER AMERICA

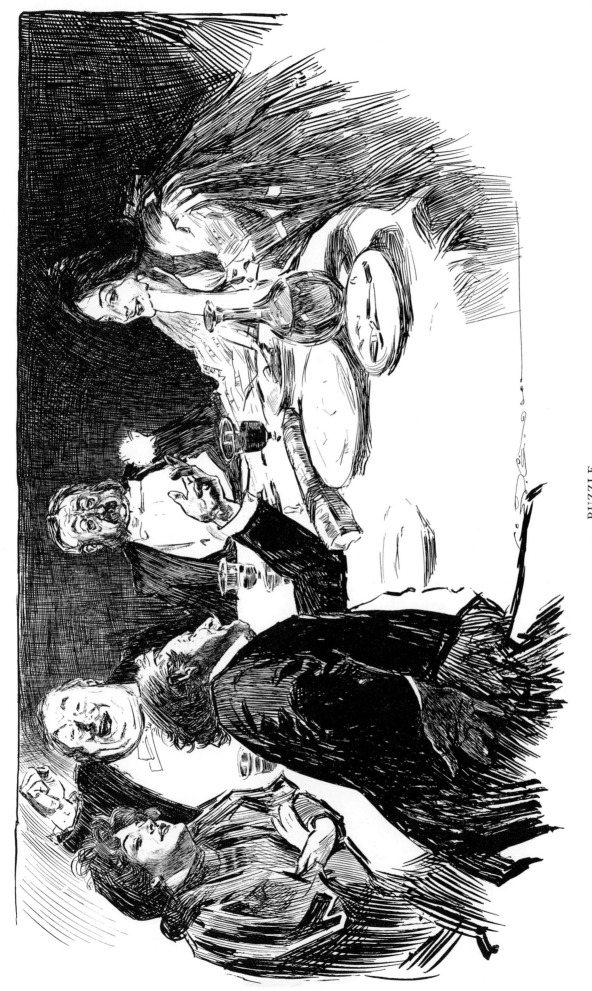

PUZZLE
A funny story. Find the Englishman.

1

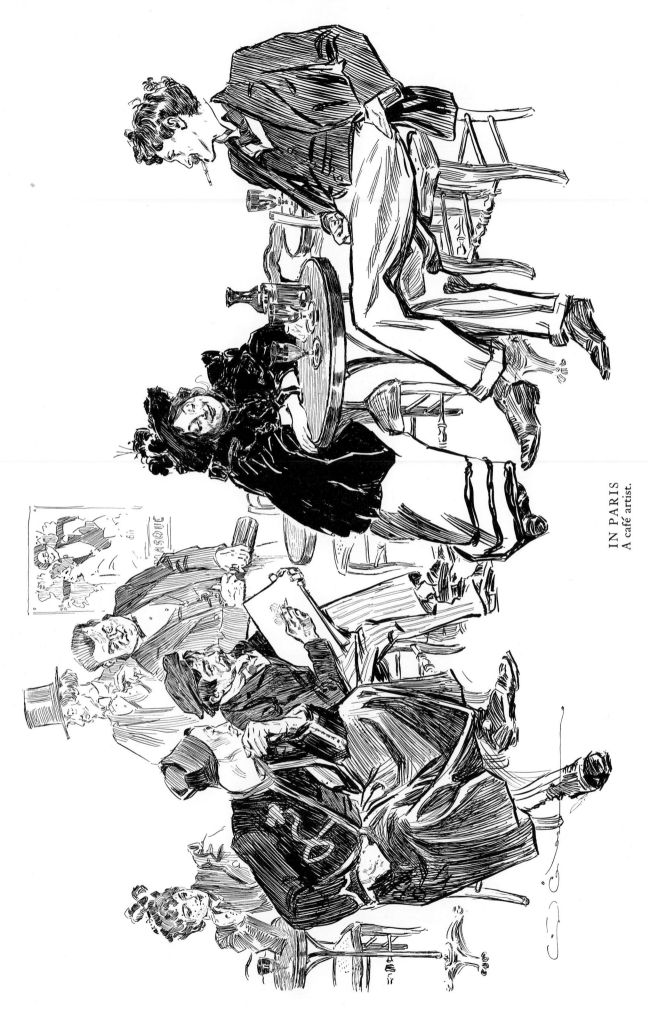

IN PARIS
A café artist.

2

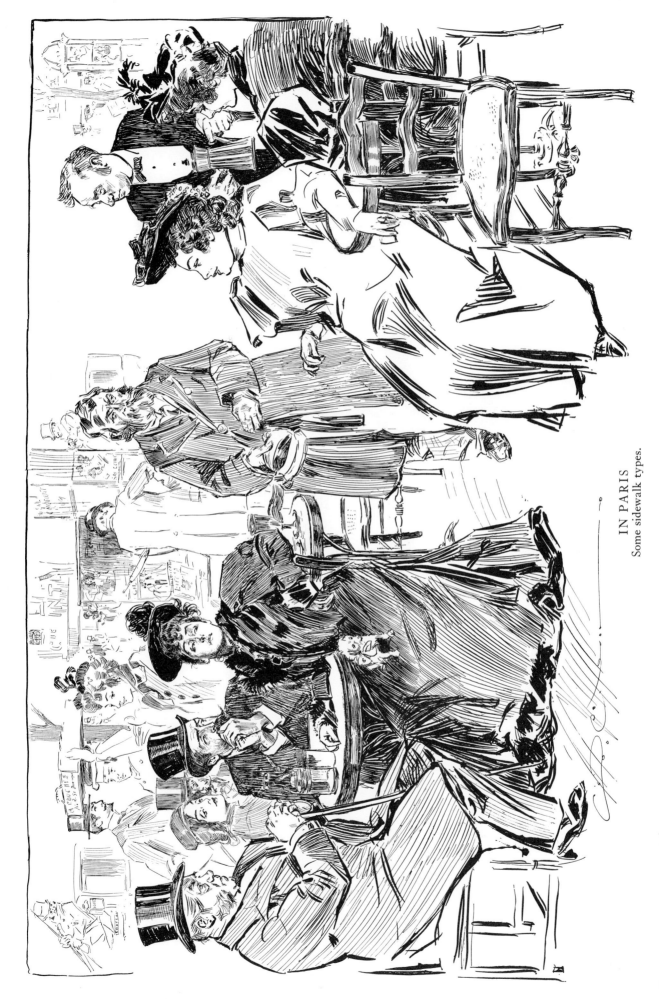

IN PARIS
Some sidewalk types.

3

PICTURES OF PEOPLE

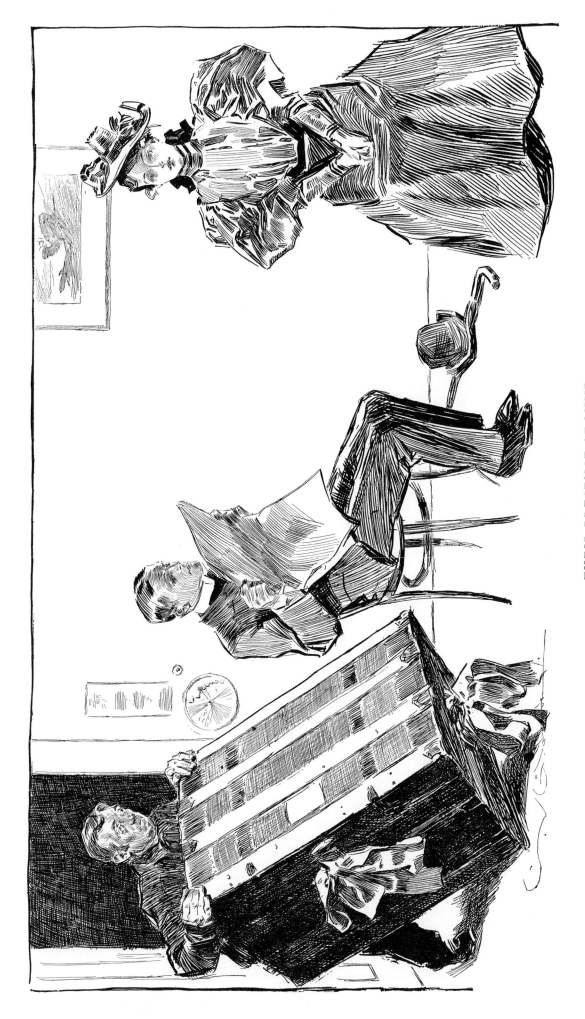

THEIR PRESENCE OF MIND

They had been in their room but a moment when they were startled by a knock.

5

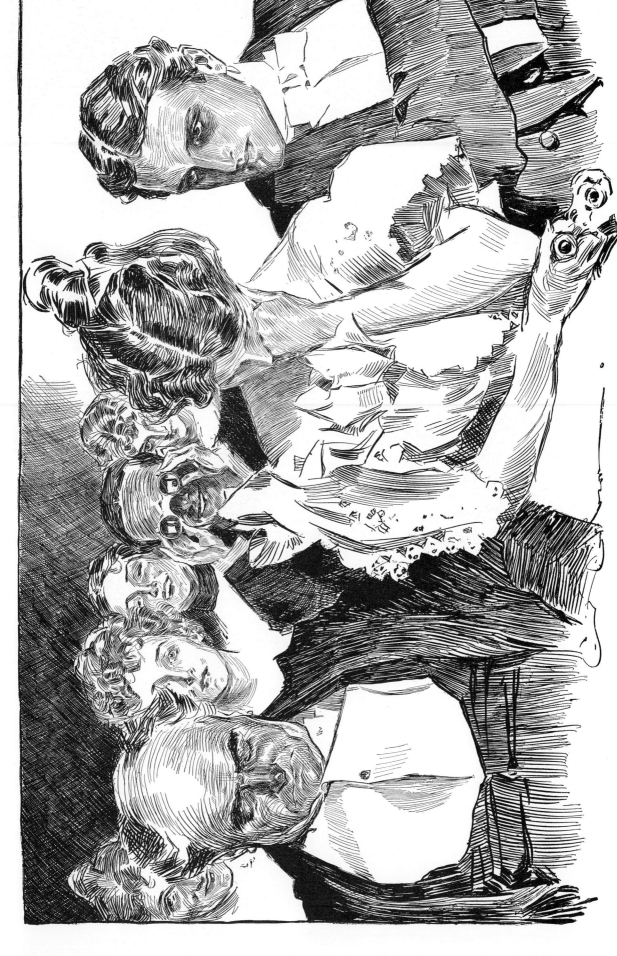

AT A COMEDY

6

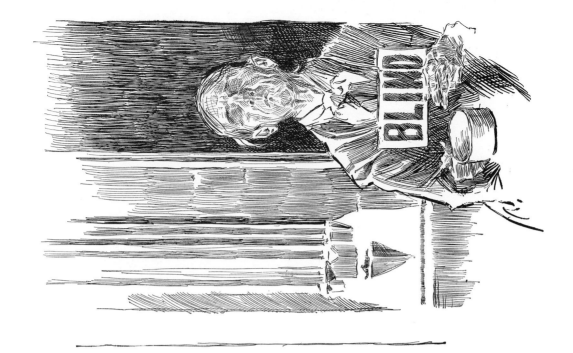

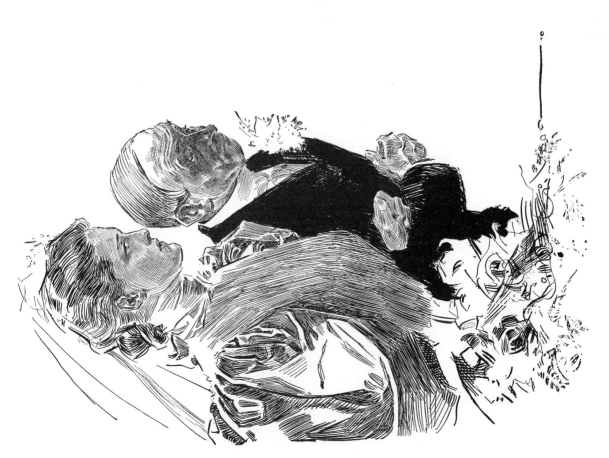

TWO BLIND WOMEN

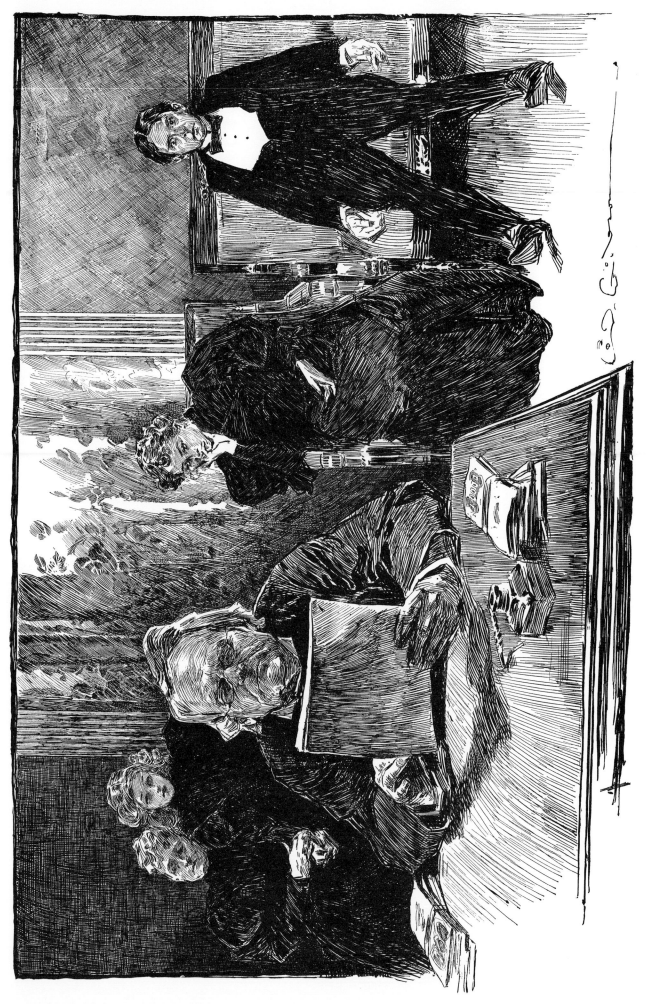

READING THE WILL

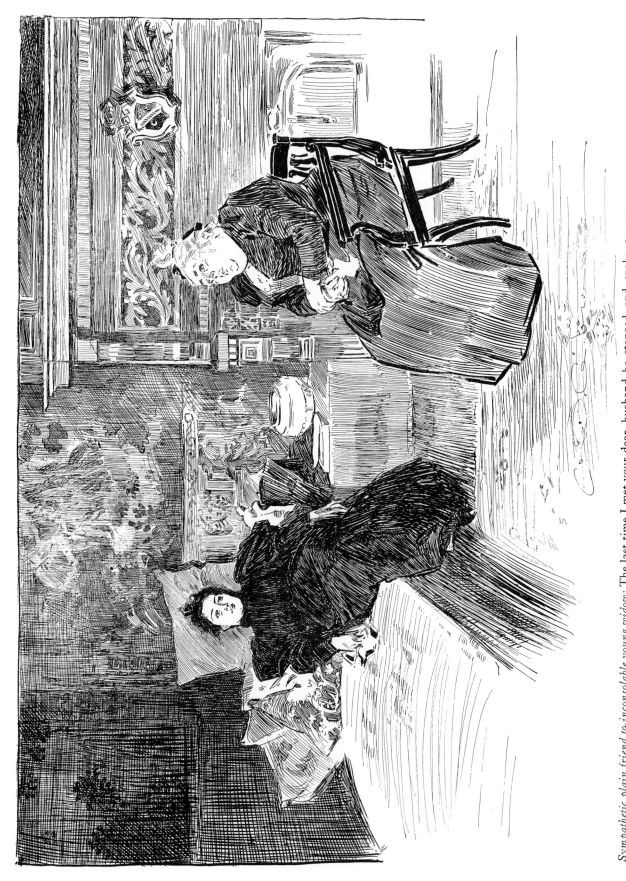

Sympathetic plain friend to inconsolable young widow: The last time I met your dear husband he stopped and spoke to me with such a sunny greeting that I was the happier for it all day long.

Young widow (still oblivious to everything except her loss): Yes, that was just like dear David. There was no woman so humble or homely, or unattractive, or dull, but that he could find something pleasant to say to her, and would take pains to say it.

WHEN OUR ECCENTRIC RELATIVE BECOMES AN OBJECT OF INTEREST

THE LAST DAY OF SUMMER

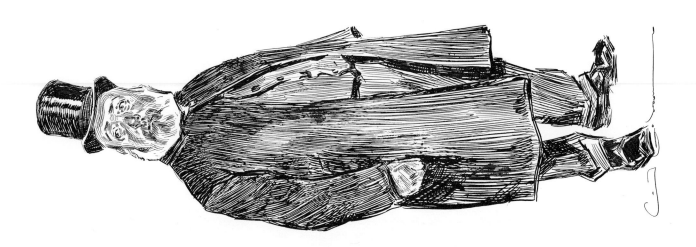

A PARK ORATOR

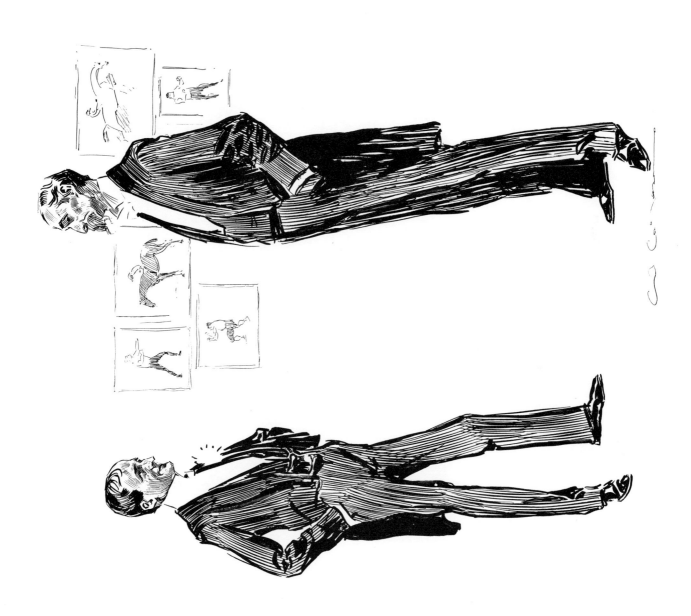

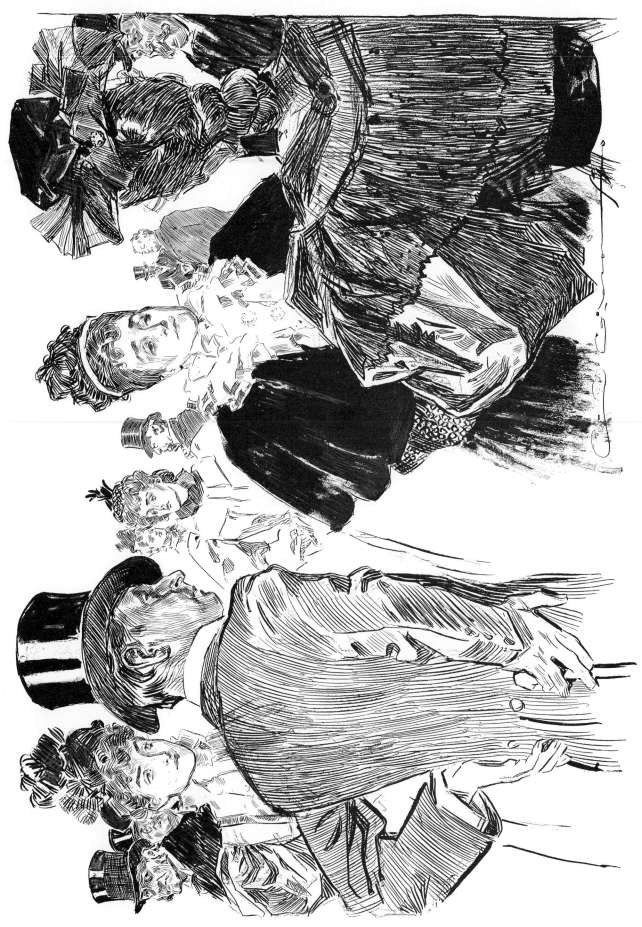

ON BOND STREET

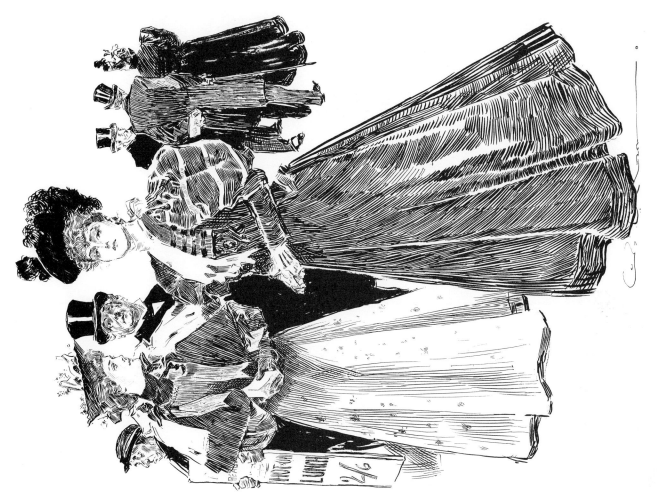

HYDE PARK CORNER

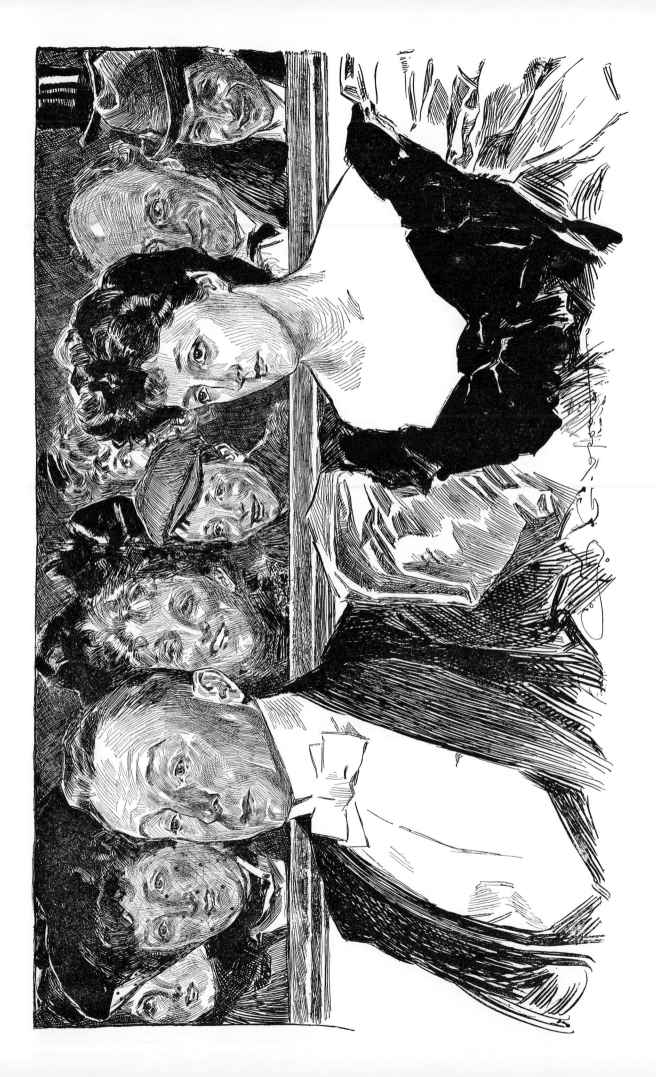

IN A LONDON THEATRE

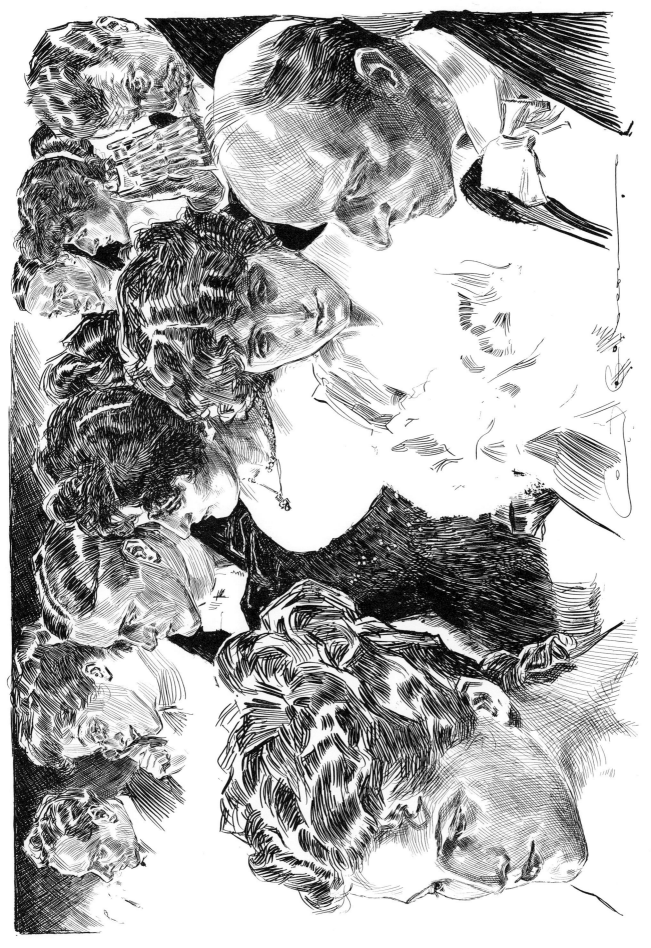

A FIRST NIGHT

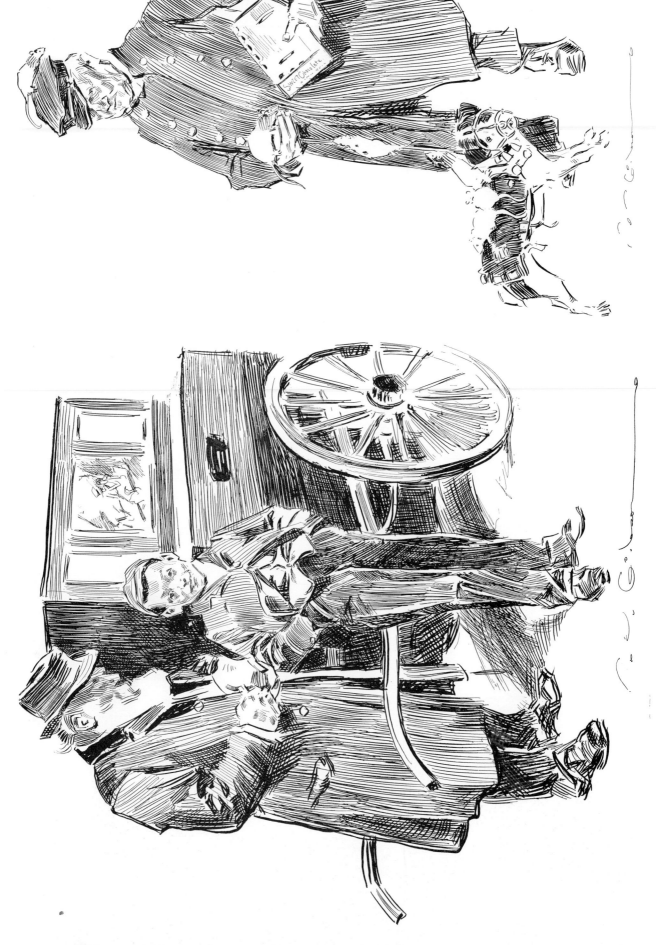

THE RAT MAN

BETWEEN TIMES, LEICESTER SQUARE

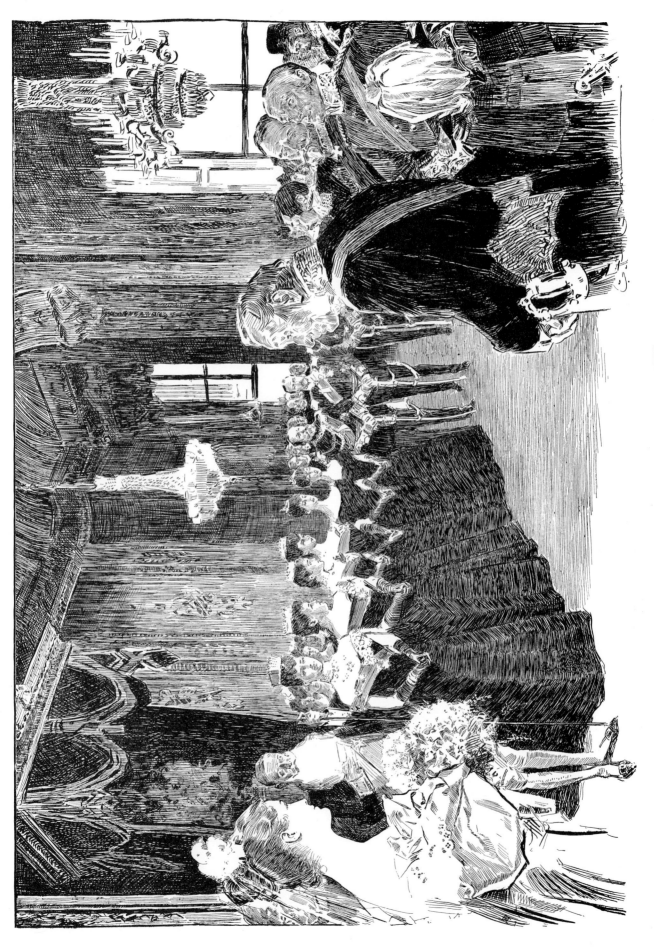

HER FIRST GLIMPSE OF ROYALTY

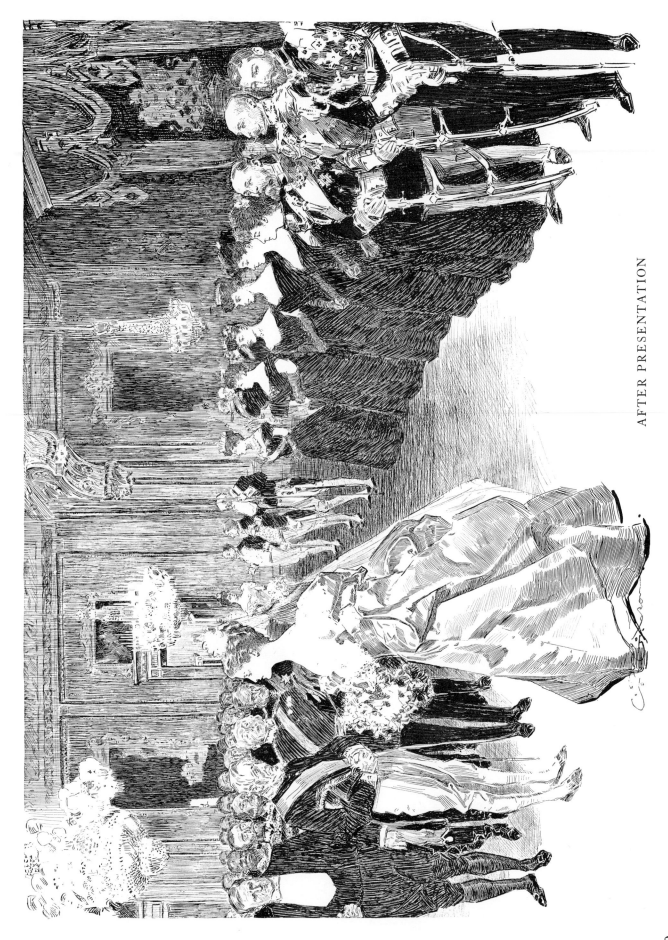

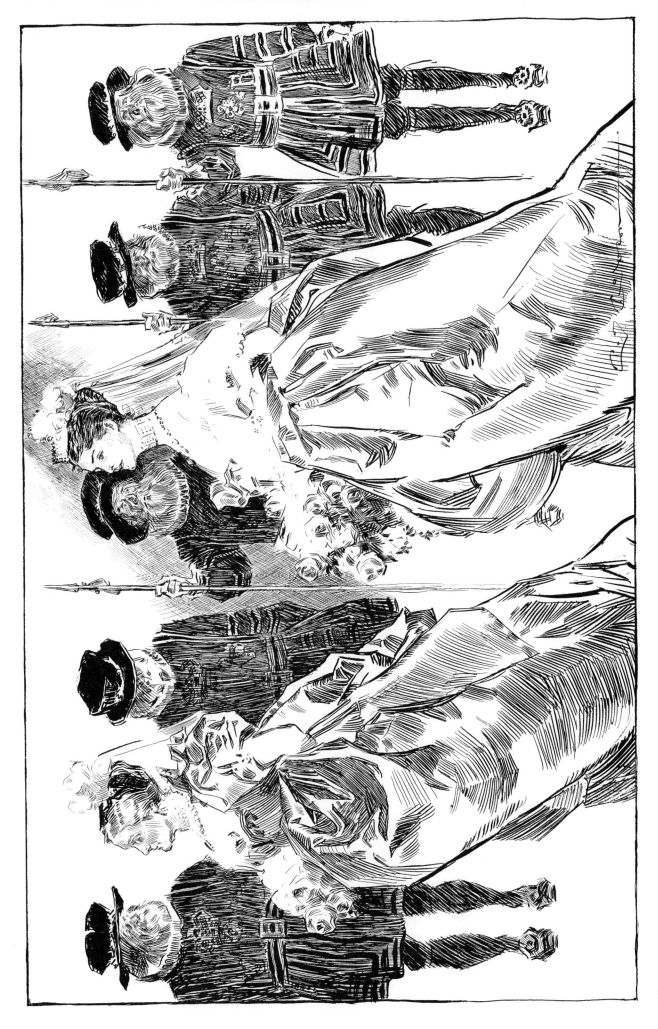

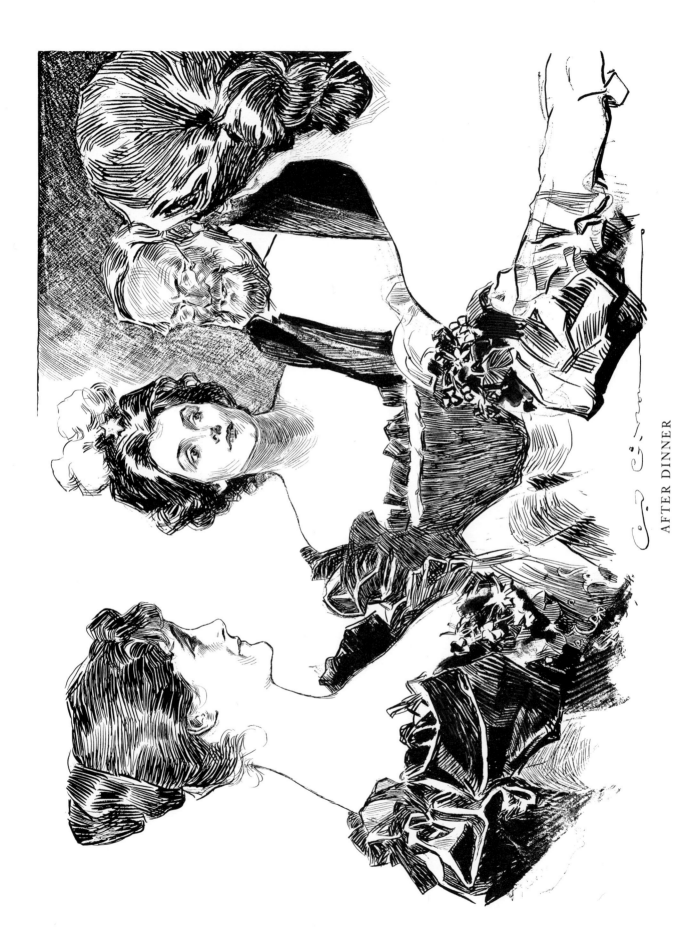

AFTER DINNER

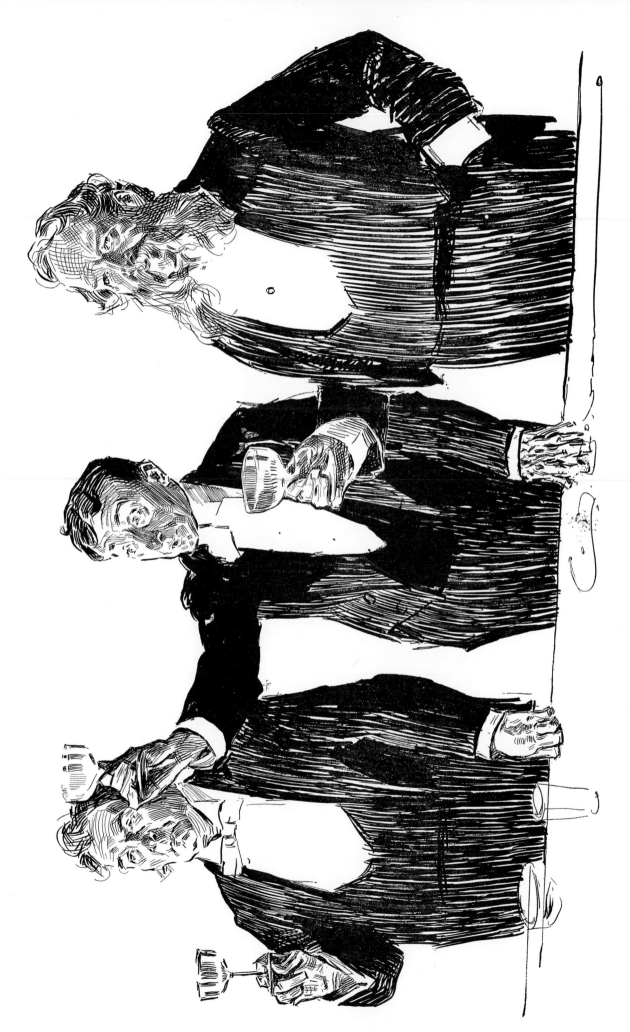

THE QUEEN

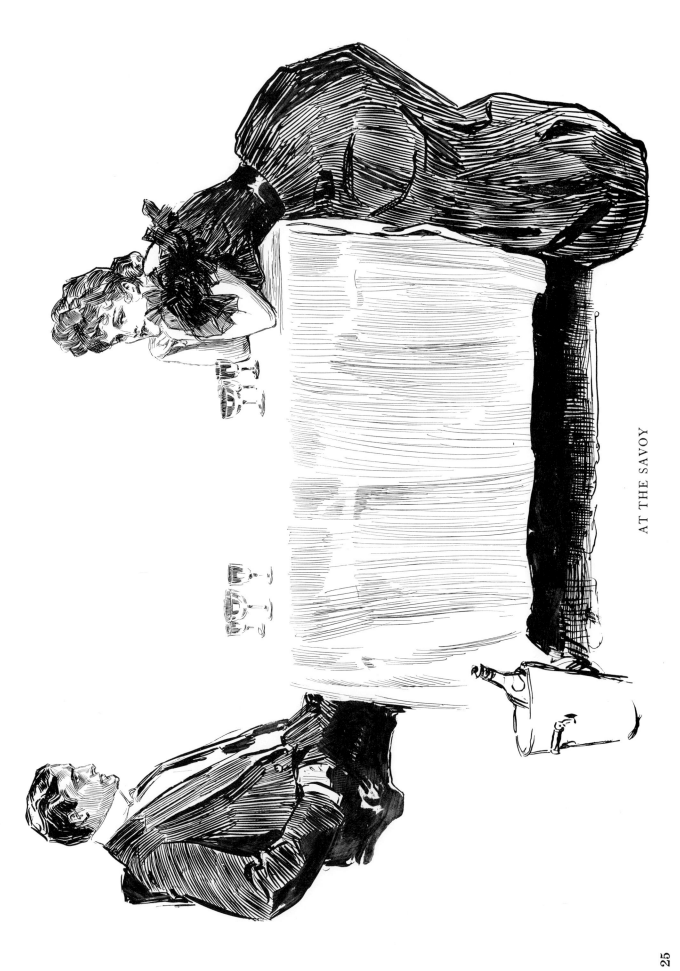

AT THE SAVOY

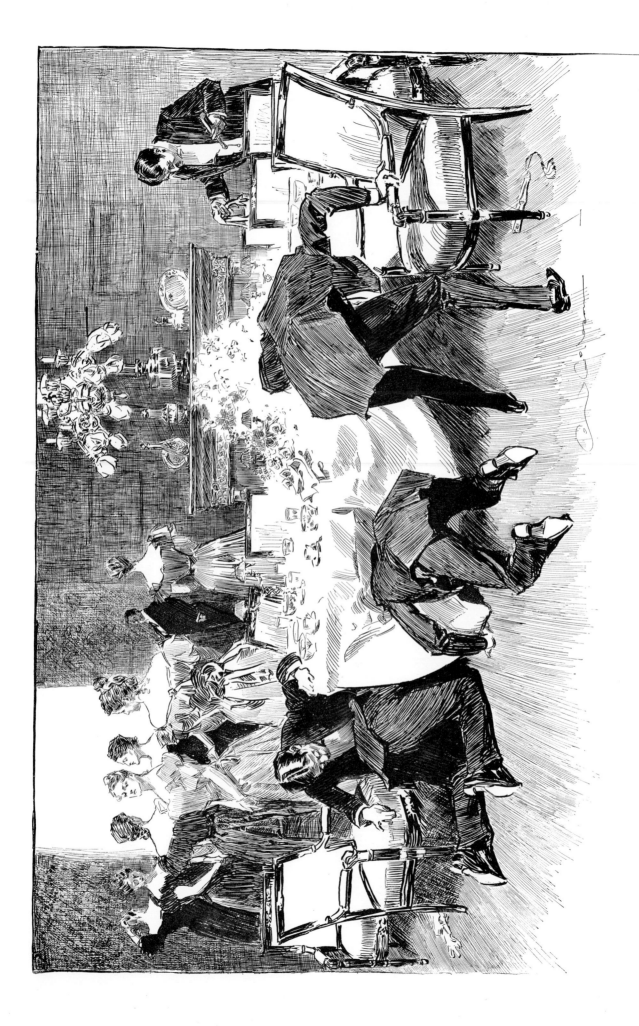

THEY ARE ONLY COLLECTING THE USUAL FANS AND GLOVES

INAUGURATION DAY IN THE DIPLOMATIC GALLERY, WASHINGTON

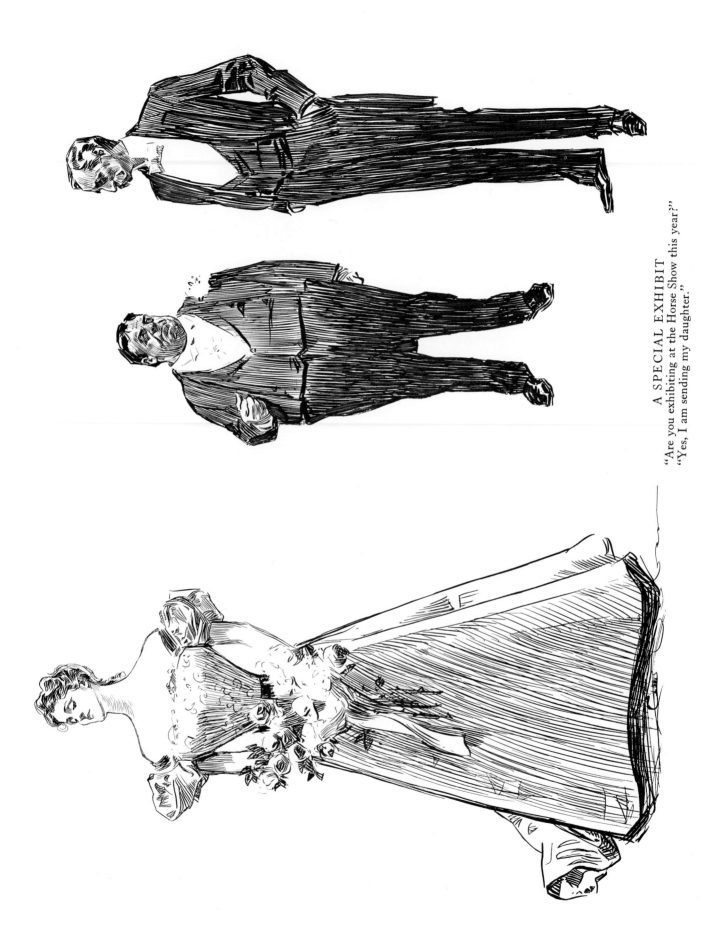

A SPECIAL EXHIBIT
"Are you exhibiting at the Horse Show this year?"
"Yes, I am sending my daughter."

28

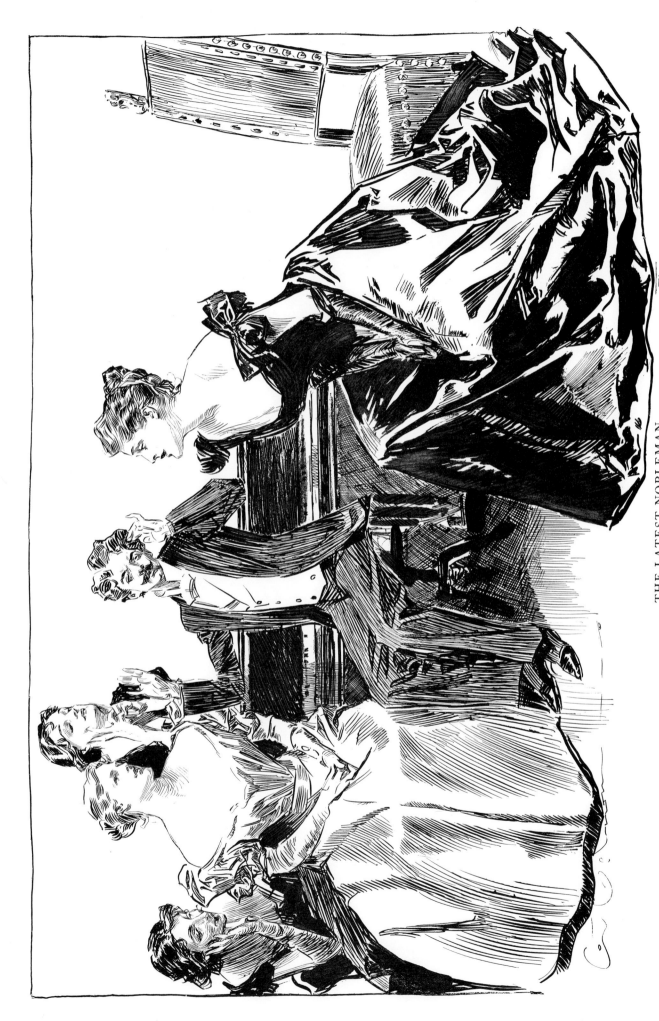

THE LATEST NOBLEMAN

"Girls, girls, don't press his Grace! He can only take one of you, and with him it is purely a matter of business."

"THE ONLY PEBBLE ON THE BEACH"

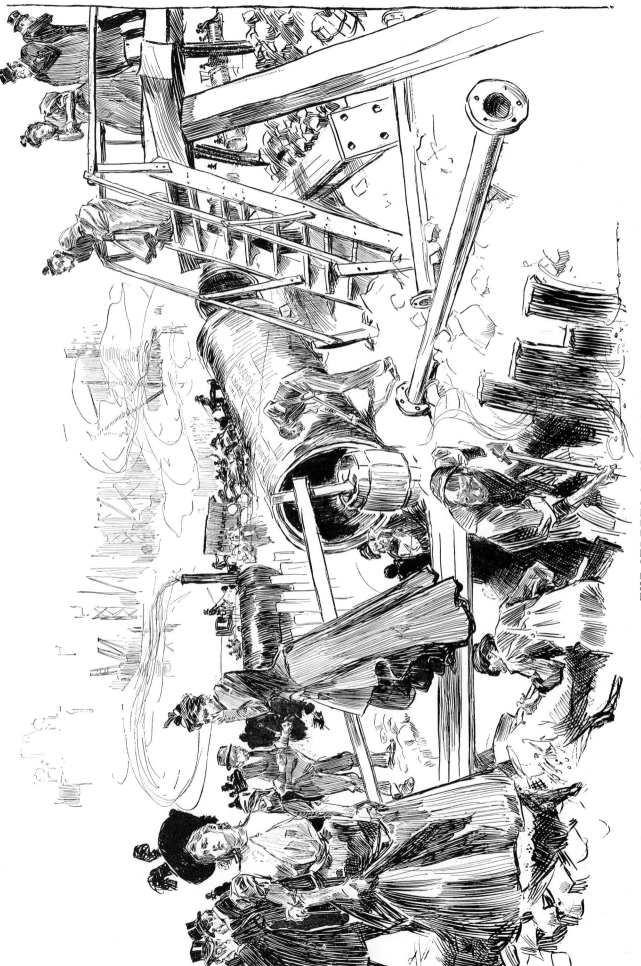

THE STREETS OF NEW YORK

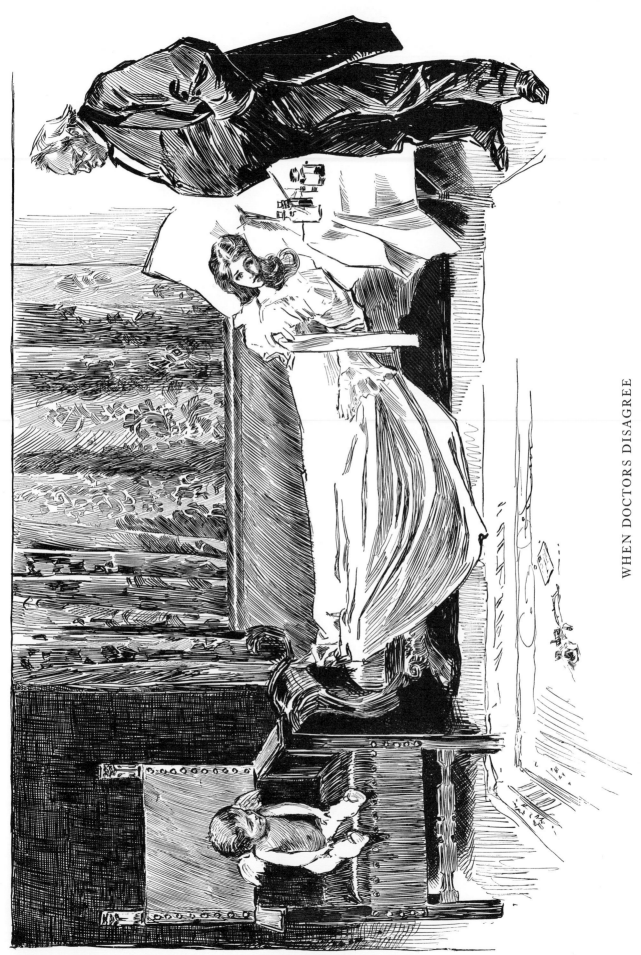

WHEN DOCTORS DISAGREE

THE EDUCATION OF MR. PIPP

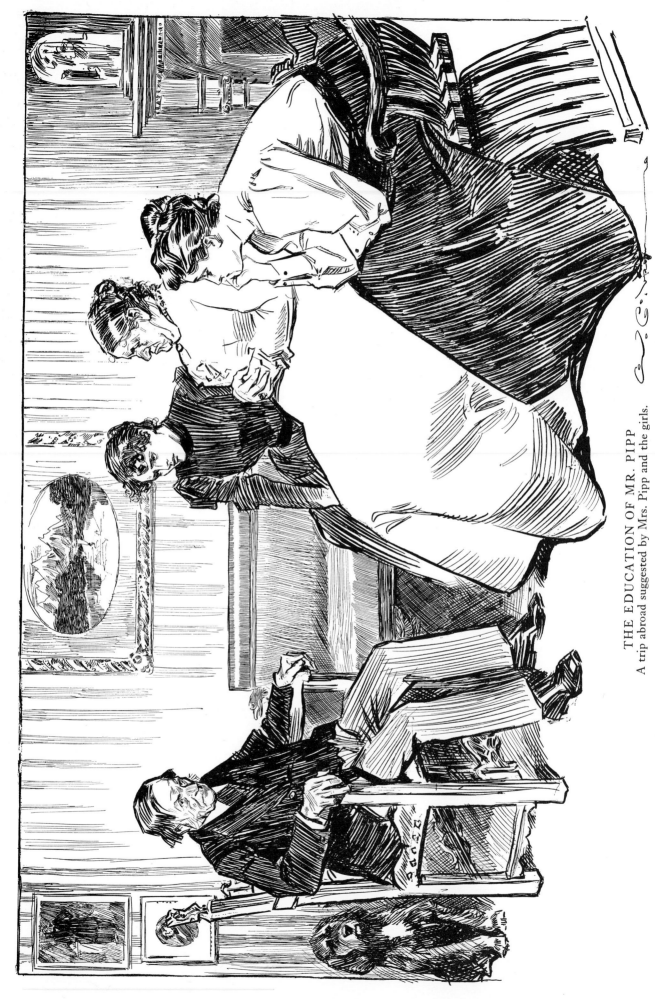

THE EDUCATION OF MR. PIPP
A trip abroad suggested by Mrs. Pipp and the girls.

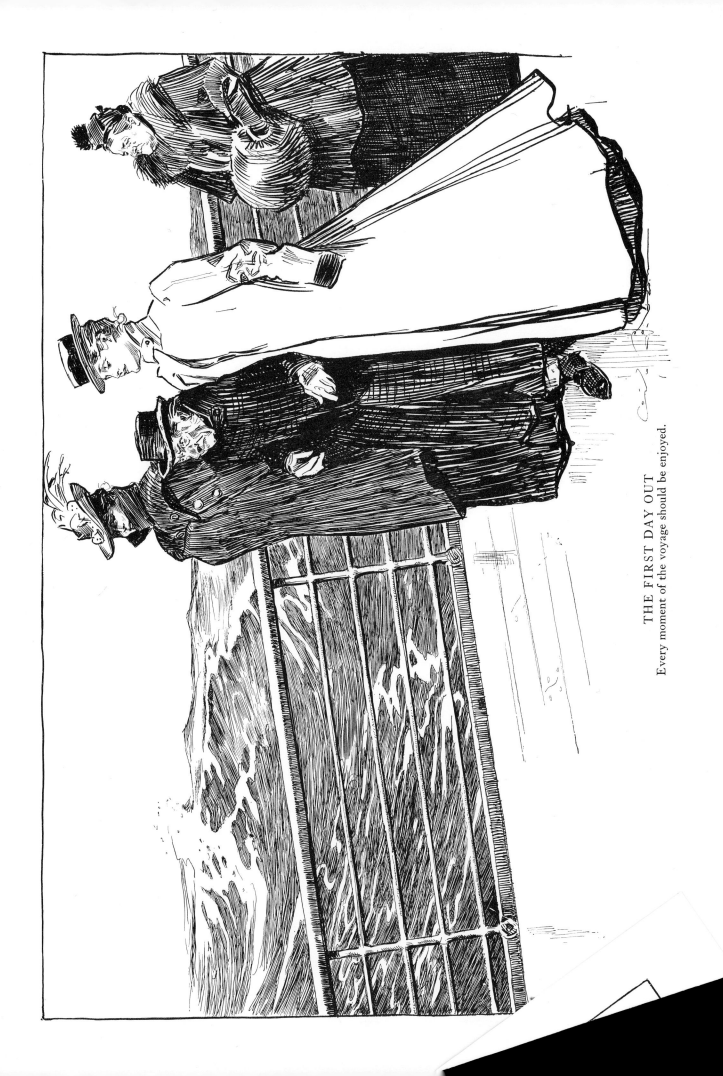

THE FIRST DAY OUT

Every moment of the voyage should be enjoyed.

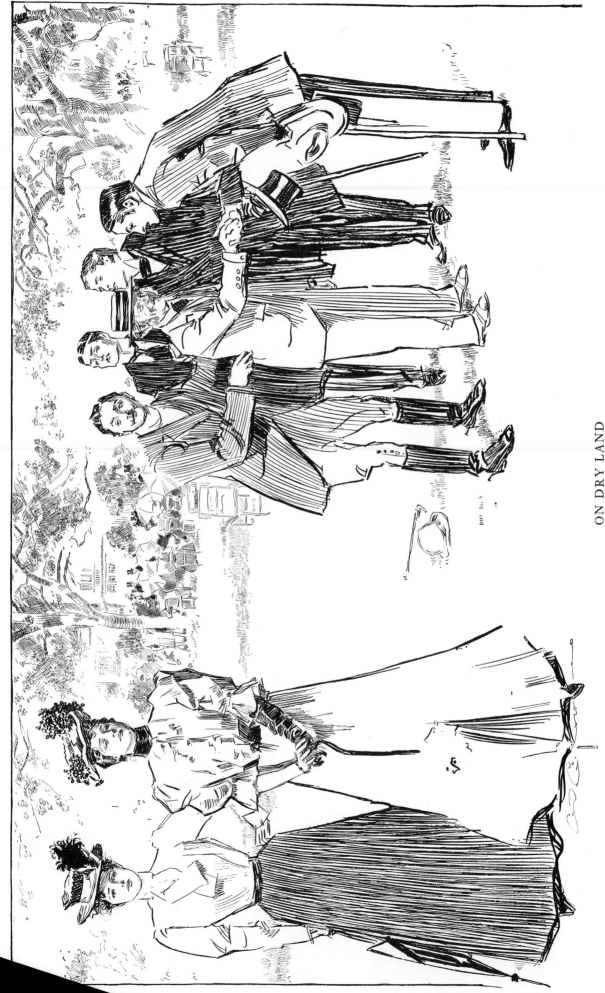

ON DRY LAND

He is much gratified at the attention shown him while in London.

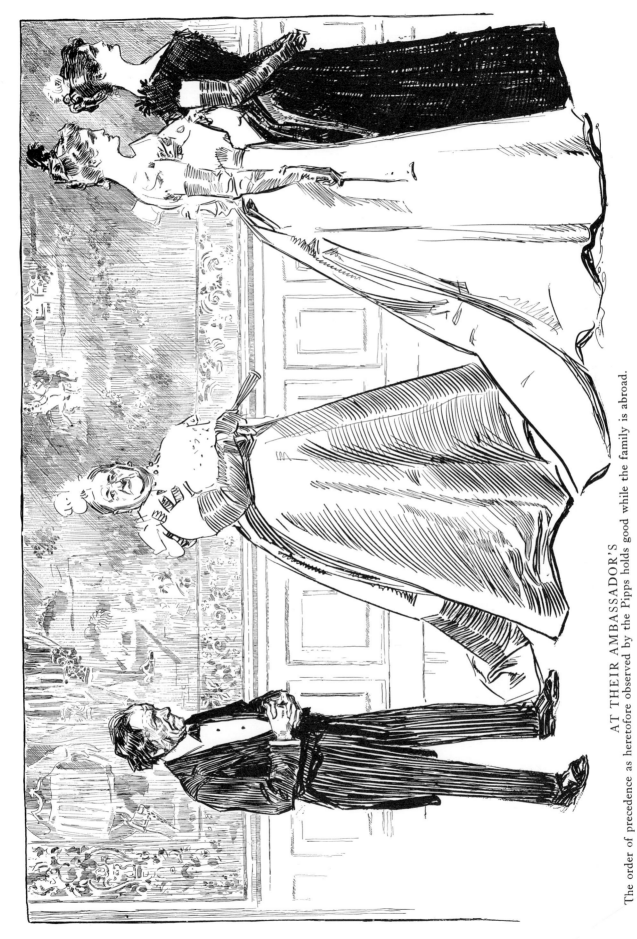

AT THEIR AMBASSADOR'S

The order of precedence as heretofore observed by the Pipps holds good while the family is abroad.

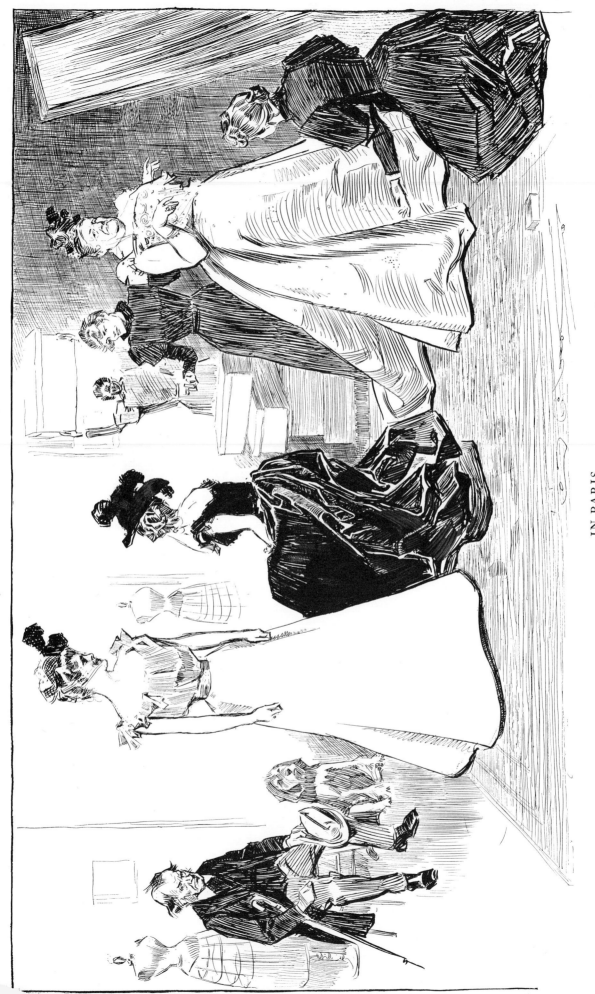

IN PARIS

He has the opportunity of enlarging his horizon and of developing an interest in the real purpose of the trip.

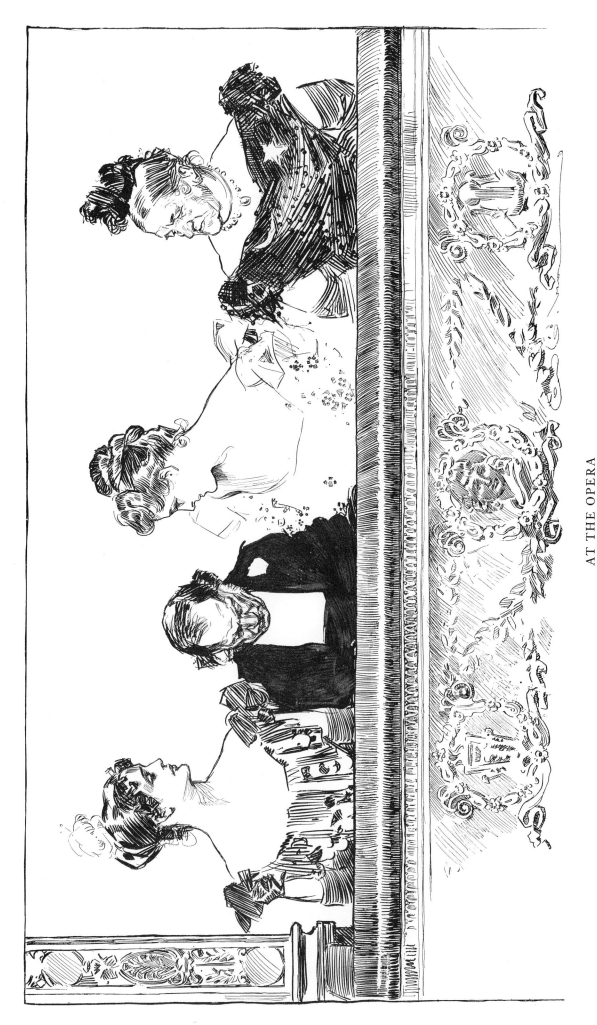

AT THE OPERA

He fails to take a friendly interest in the great composers.

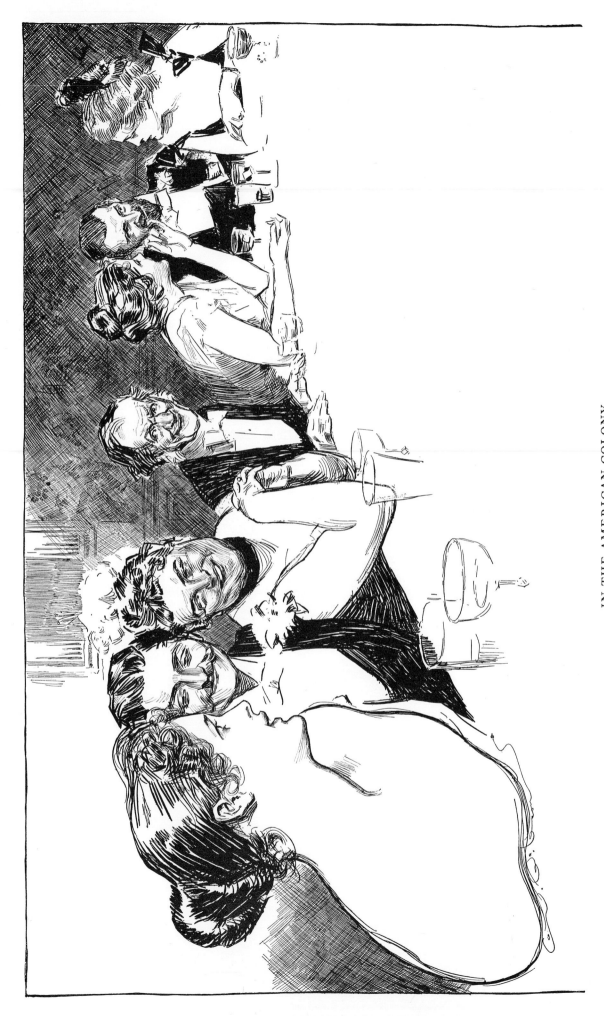

IN THE AMERICAN COLONY

On this occasion Mr. Pipp follows instructions he has received and appears interested.

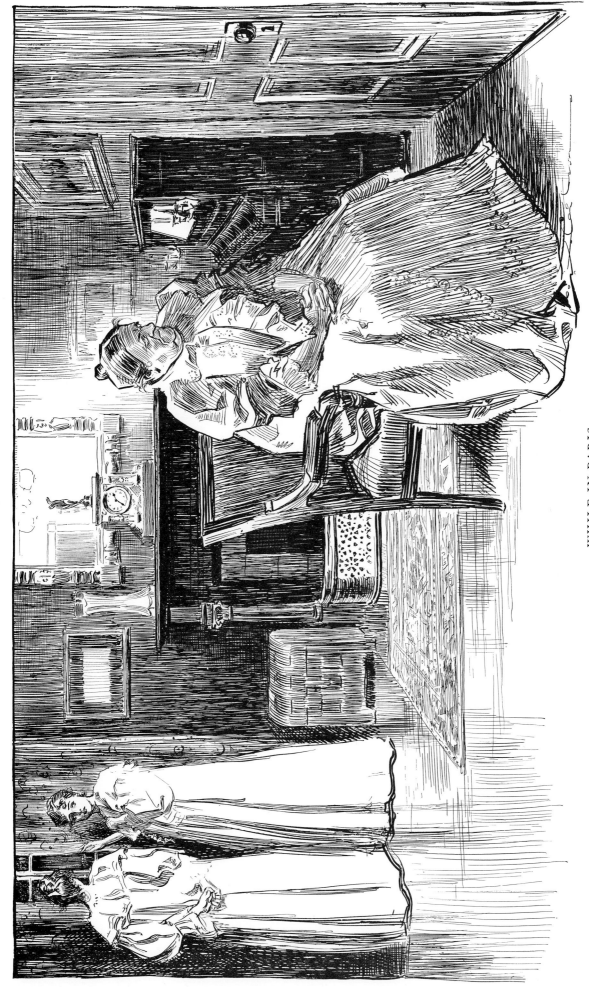

WHILE IN PARIS

Mr. Pipp, just after dinner, steps out for a few moments with a chance acquaintance.

41

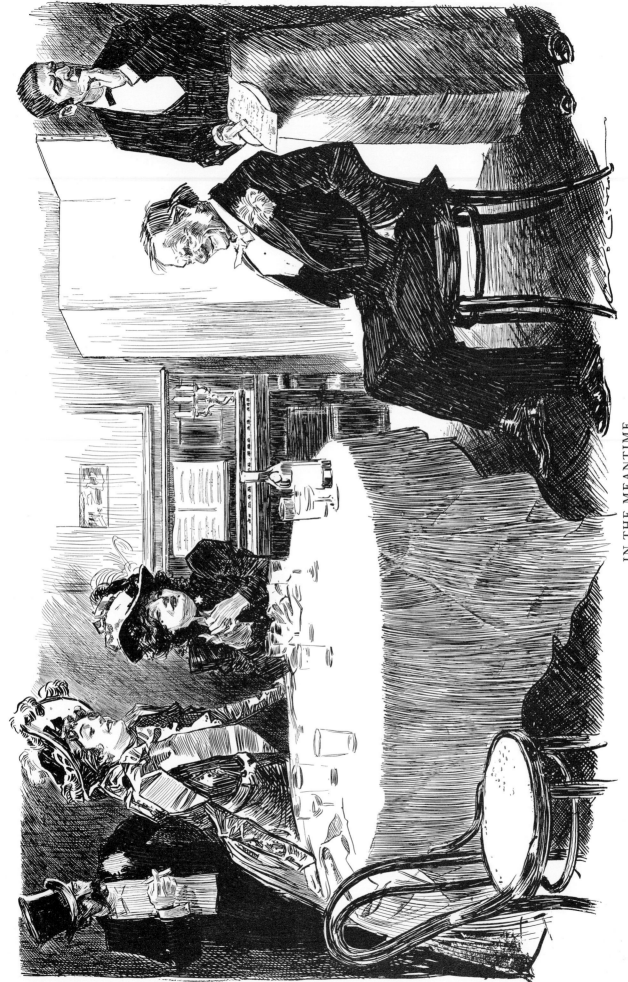

IN THE MEANTIME

Mr. Pipp has been enlarging his acquaintance. His new friends become so flattering in their manner that his French is not equal to the occasion.

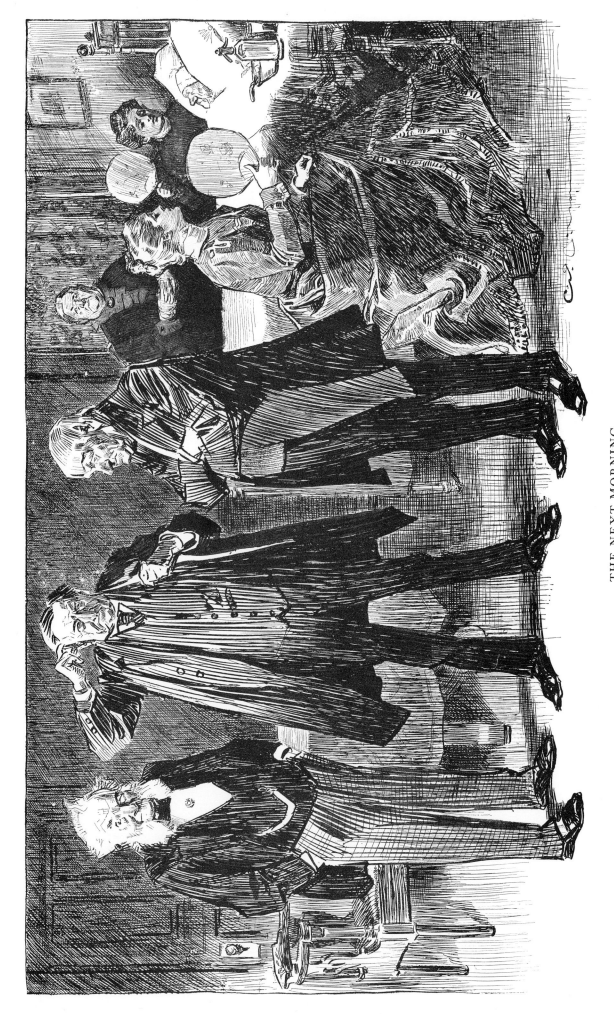

THE NEXT MORNING

Mr. Pipp having developed unusual symptoms, the best medical advice is secured.

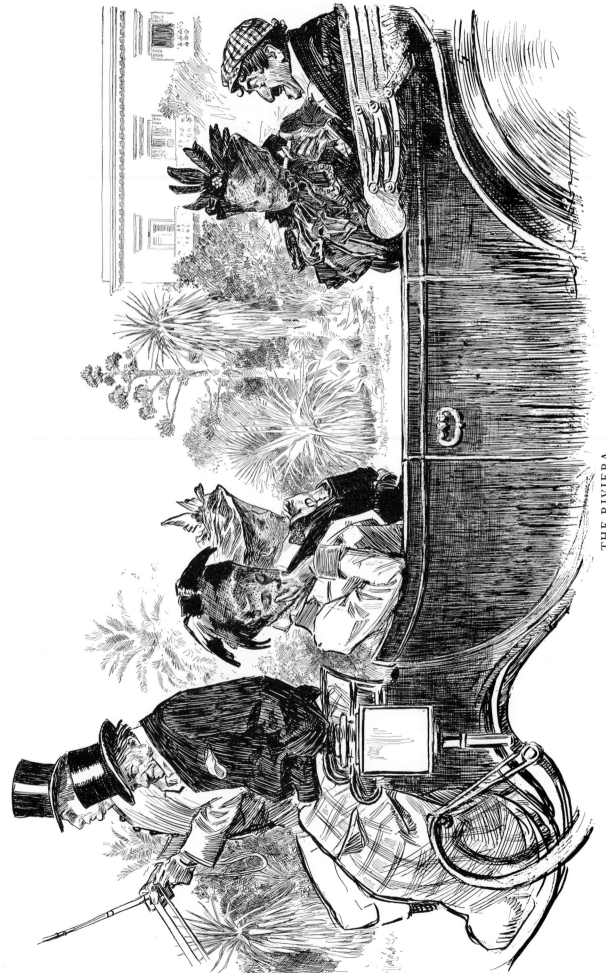

THE RIVIERA

A change of climate having been ordered for Mr. Pipp, a reduced nobleman condescends to act as courier, to the delight of Mrs. Pipp.

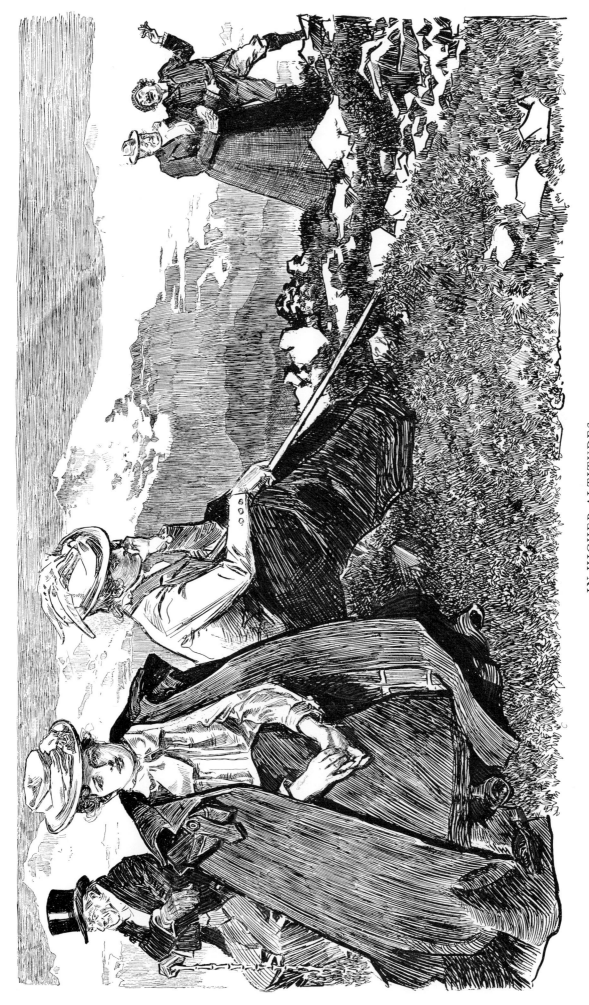

IN HIGHER ALTITUDES

There is a difference of opinion, in the family, regarding the courier.

45

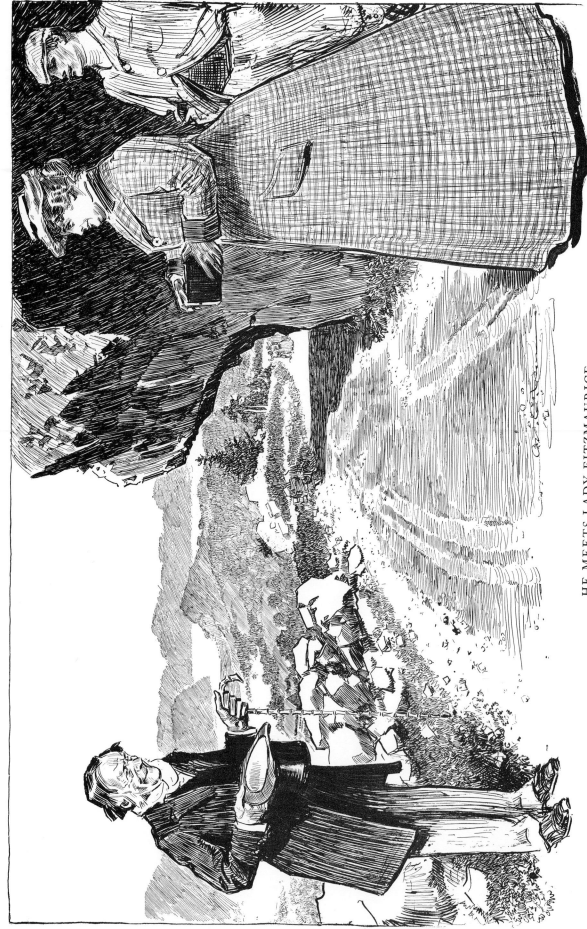

HE MEETS LADY FITZMAURICE

Being in advance of the rest of the party, Mr. Pipp meets an affable English lady and her son. She proves to be Viola, Lady Fitzmaurice, of Carony Castle, Herts, who is struck by Mr. Pipp's resemblance to her late husband, and insists on photographing him.

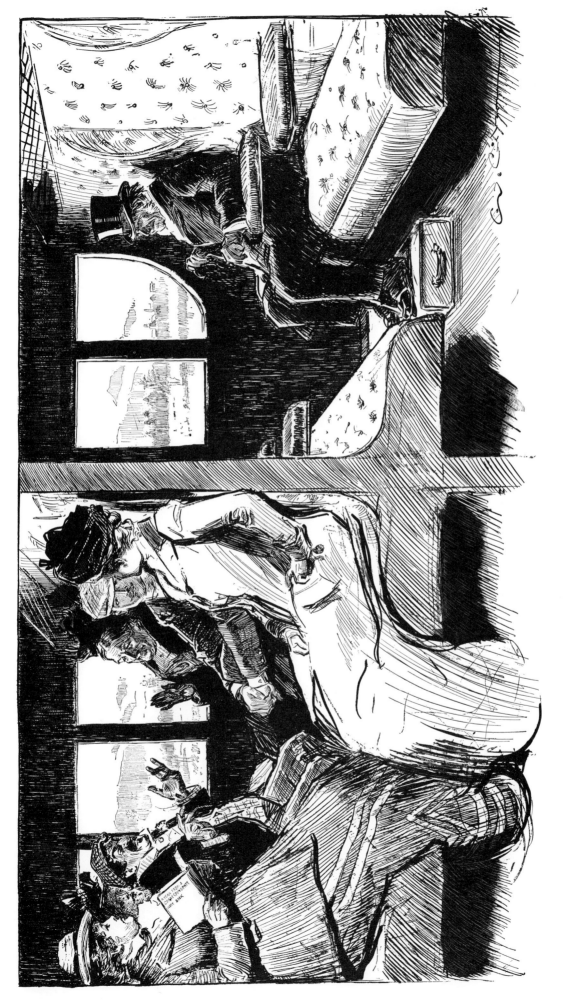

ON THEIR WAY TO ITALY
The Pipps and the Fitzmaurices start on the same train.

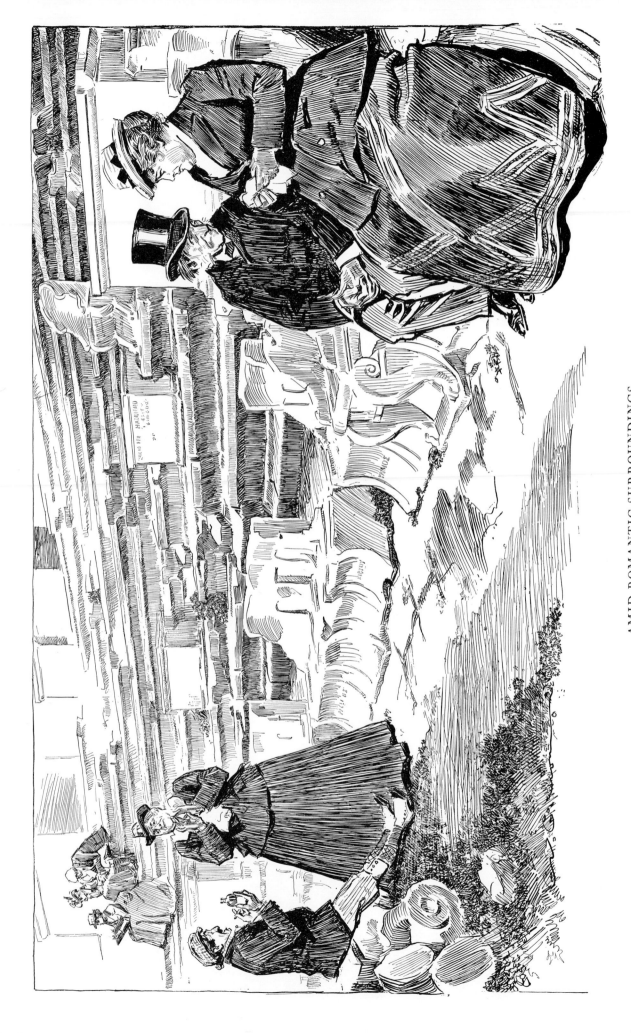

AMID ROMANTIC SURROUNDINGS

Mr. Pipp finds in Viola, Lady Fitzmaurice, a sympathetic listener; she is much affected by the story of his early life.

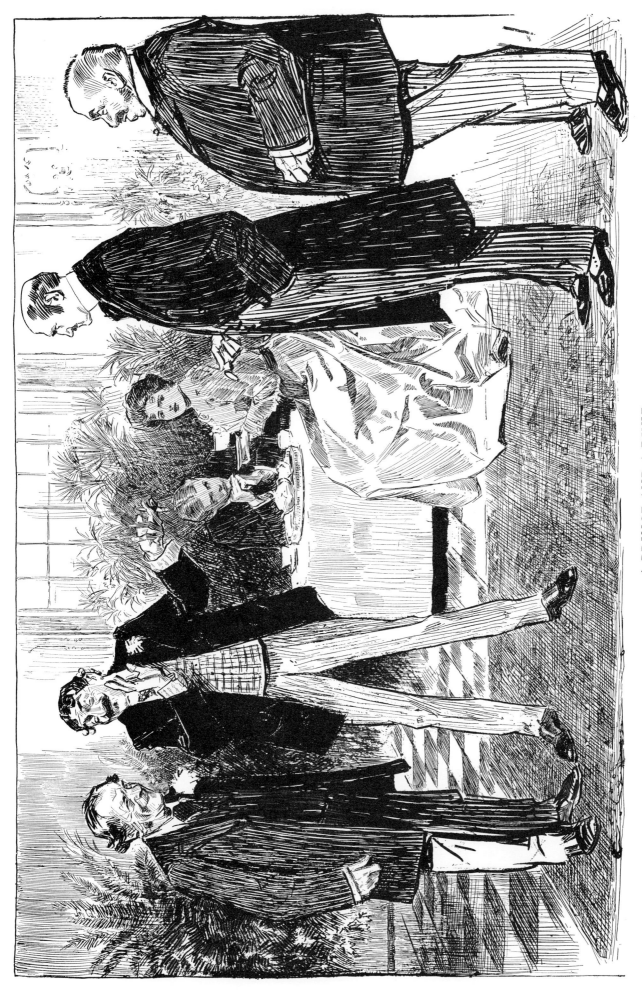

A PRINCE AND A DUKE
Mr. Pipp meets two of the courier's intimate friends.

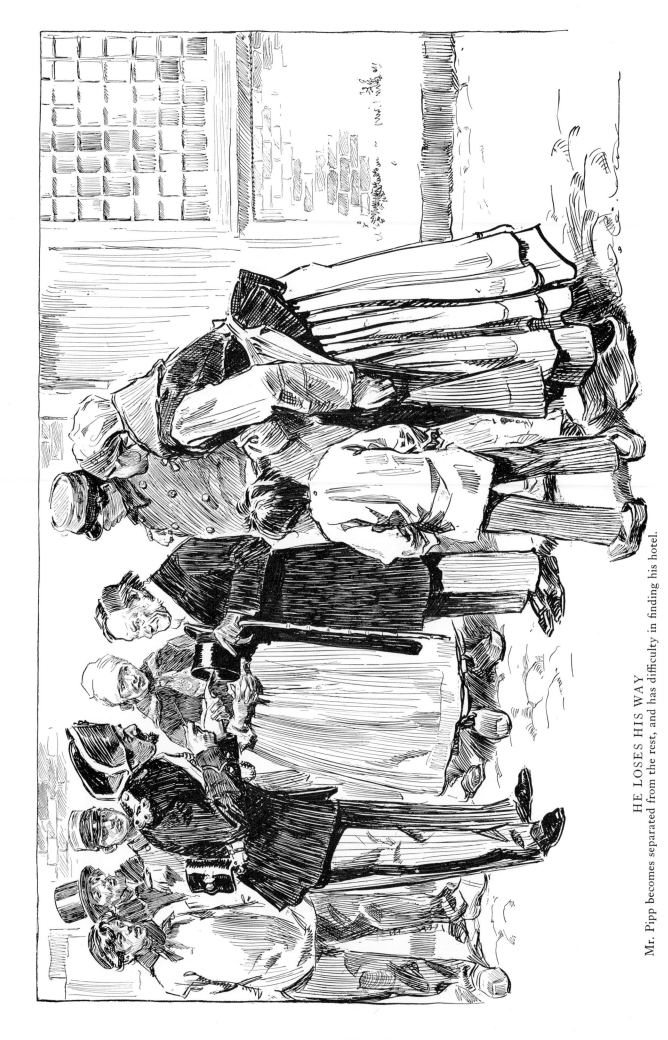

HE LOSES HIS WAY

Mr. Pipp becomes separated from the rest, and has difficulty in finding his hotel.

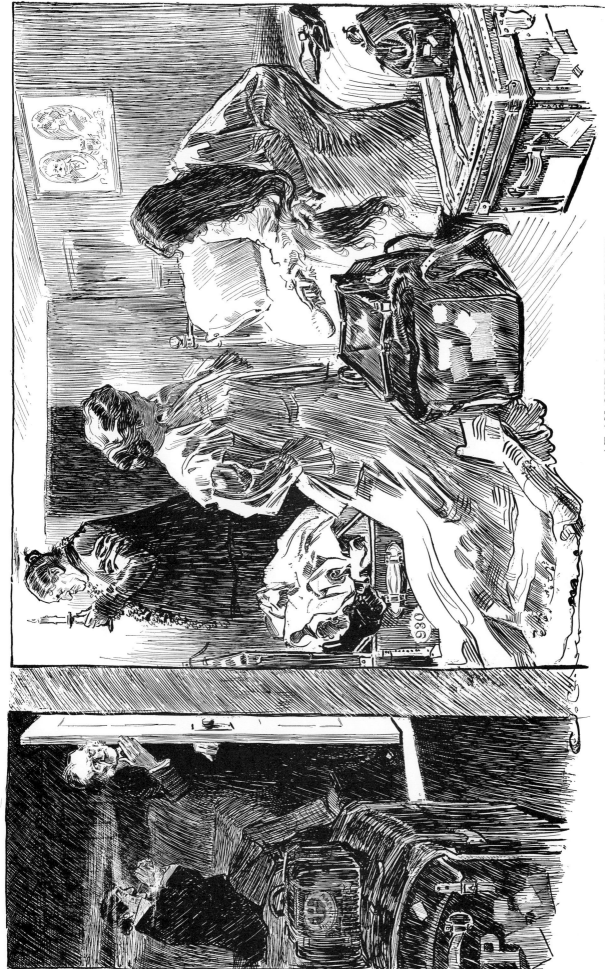

AT AN OVERCROWDED HOTEL

Mr. Pipp occupies the same room with the courier. He learns from Mrs. Pipp that the jewels are missing.

51

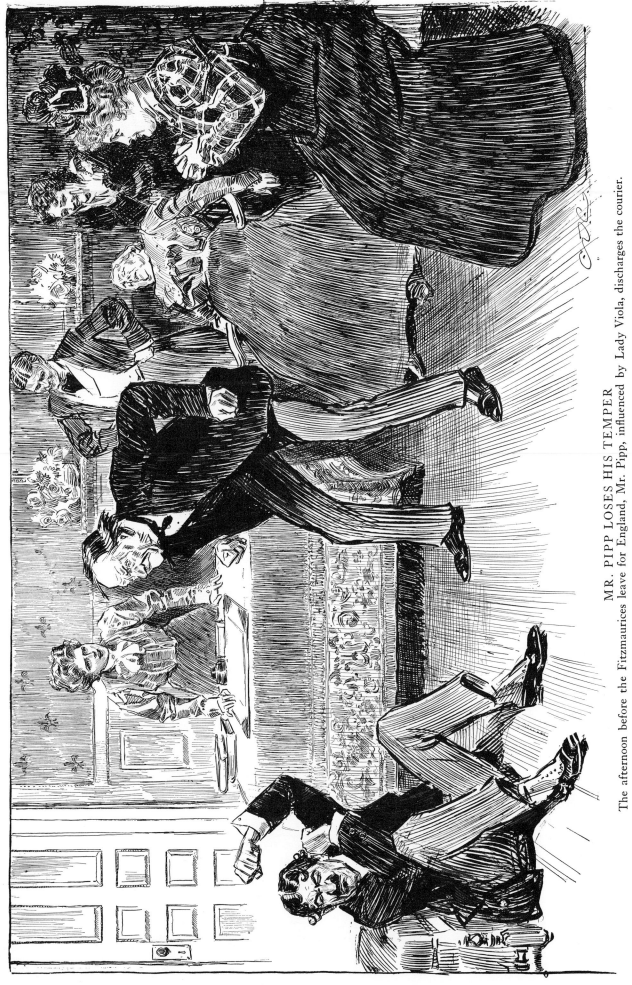

MR. PIPP LOSES HIS TEMPER

The afternoon before the Fitzmaurices leave for England, Mr. Pipp, influenced by Lady Viola, discharges the courier.

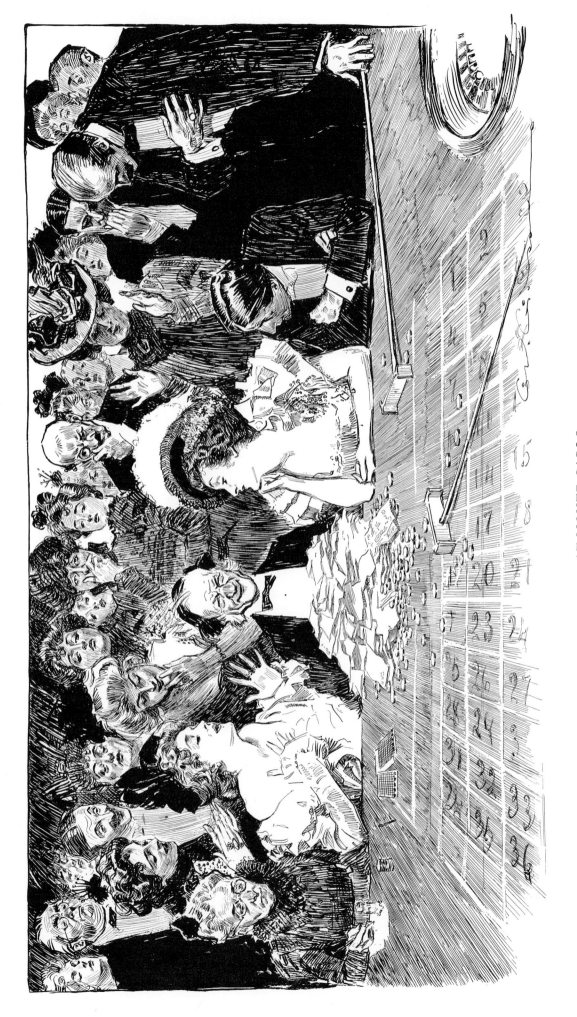

AT MONTE CARLO

Mr. Pipp's luck has changed. He breaks the bank.

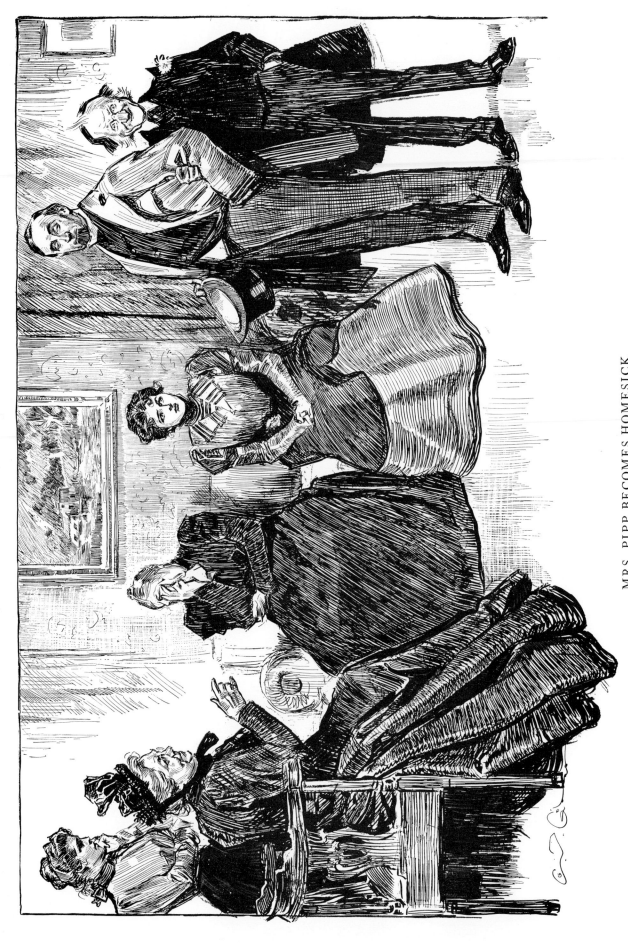

MRS. PIPP BECOMES HOMESICK

It is suggested by Congressman and Mrs. Firkin, old friends whom they have just met, that they all go home together.

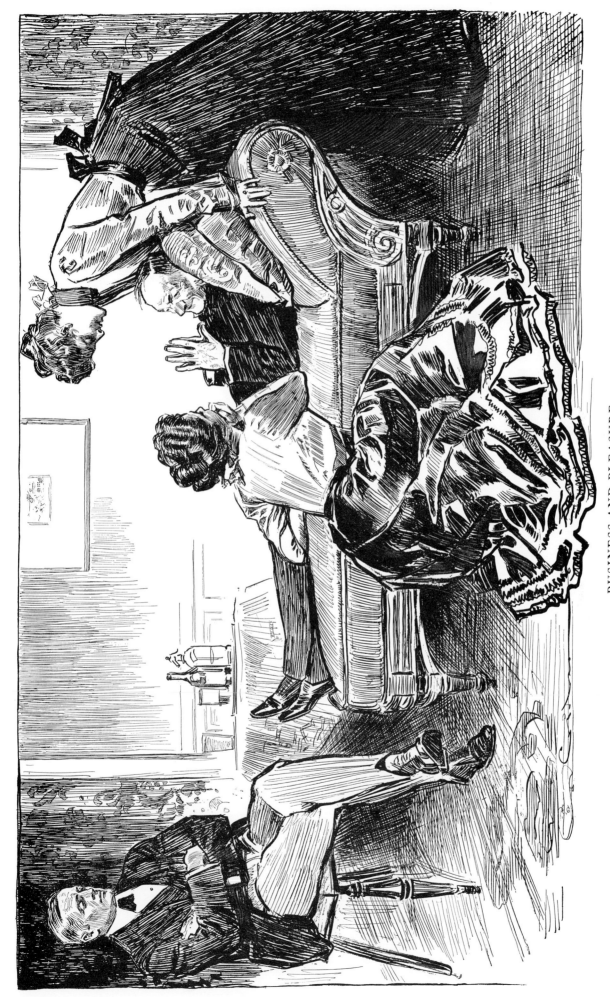

BUSINESS AND PLEASURE

Mrs. Pipp having returned to America with the Congressman and Mrs. Firkin, the girls persuade their father to take them to Paris and England. John Willing, manager of the Pipp Iron Works who has come over on business, joins the party.

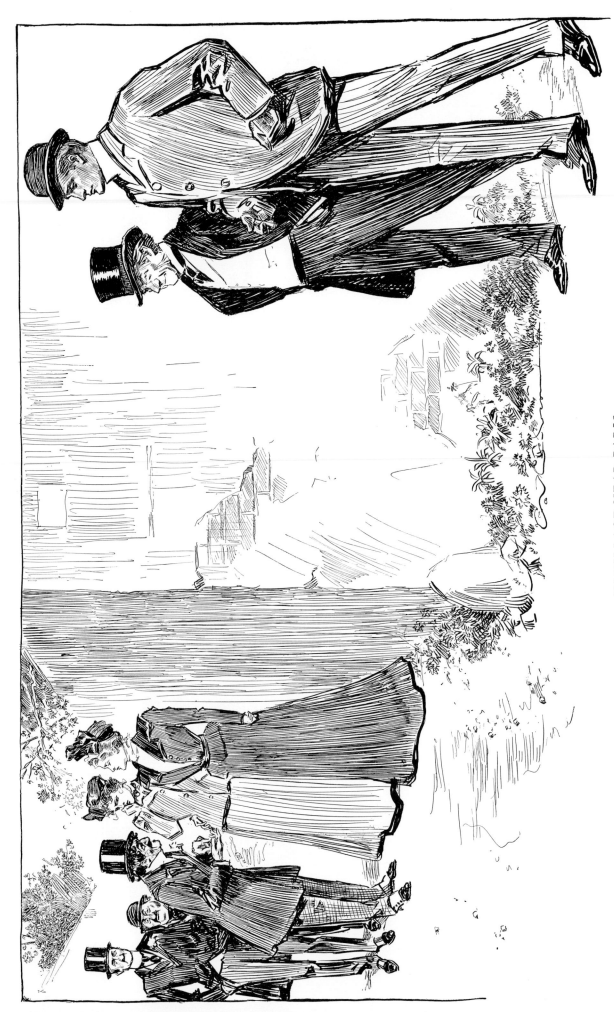

IN VILLAGE NEAR PARIS

The girls meet the courier, who supposes them to be alone.

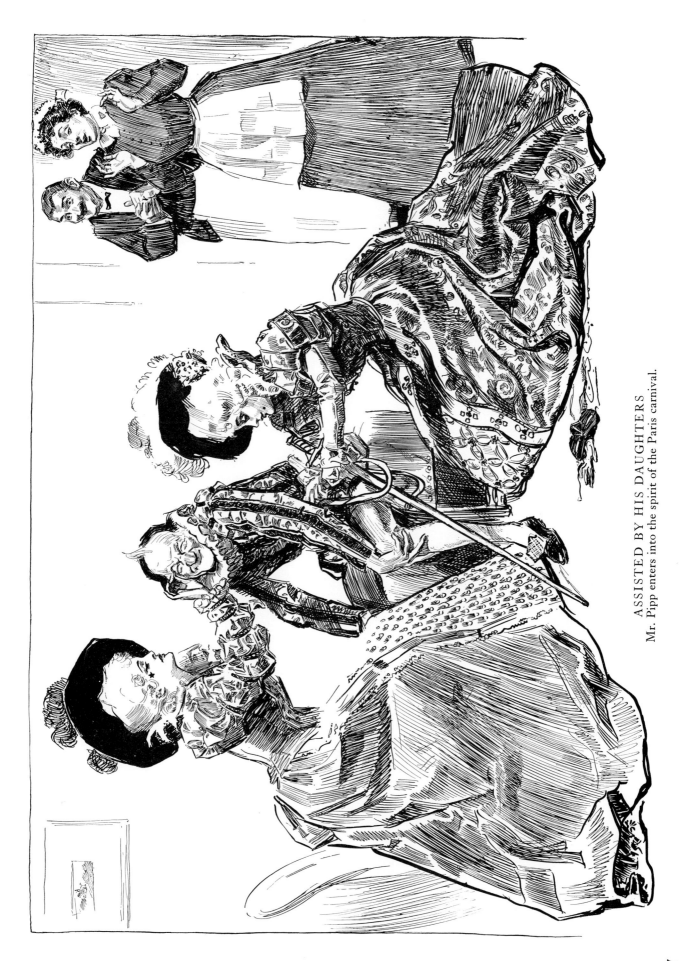

ASSISTED BY HIS DAUGHTERS
Mr. Pipp enters into the spirit of the Paris carnival.

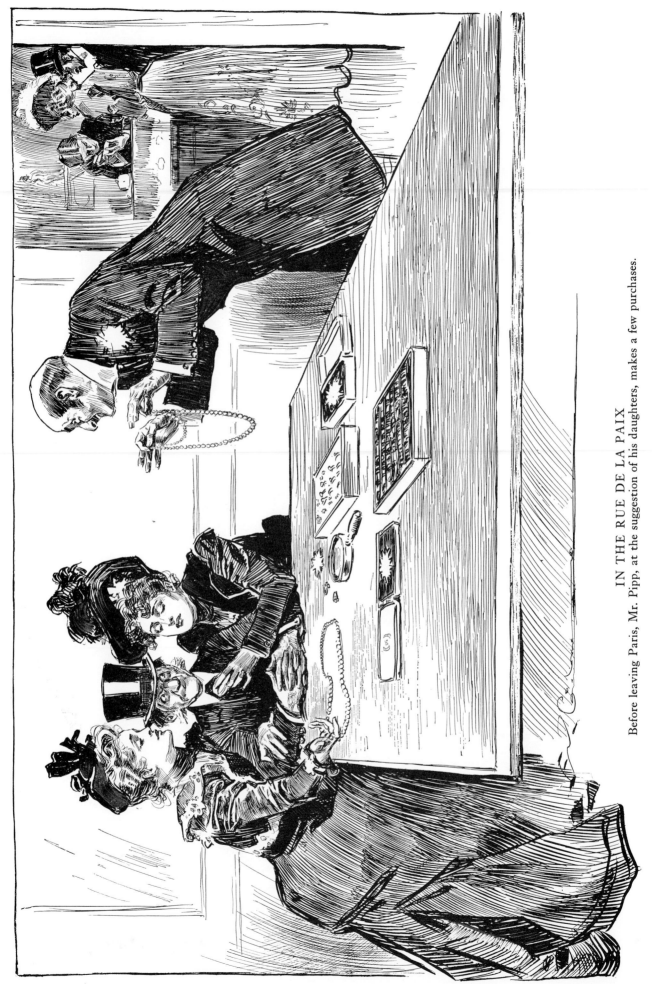

IN THE RUE DE LA PAIX

Before leaving Paris, Mr. Pipp, at the suggestion of his daughters, makes a few purchases.

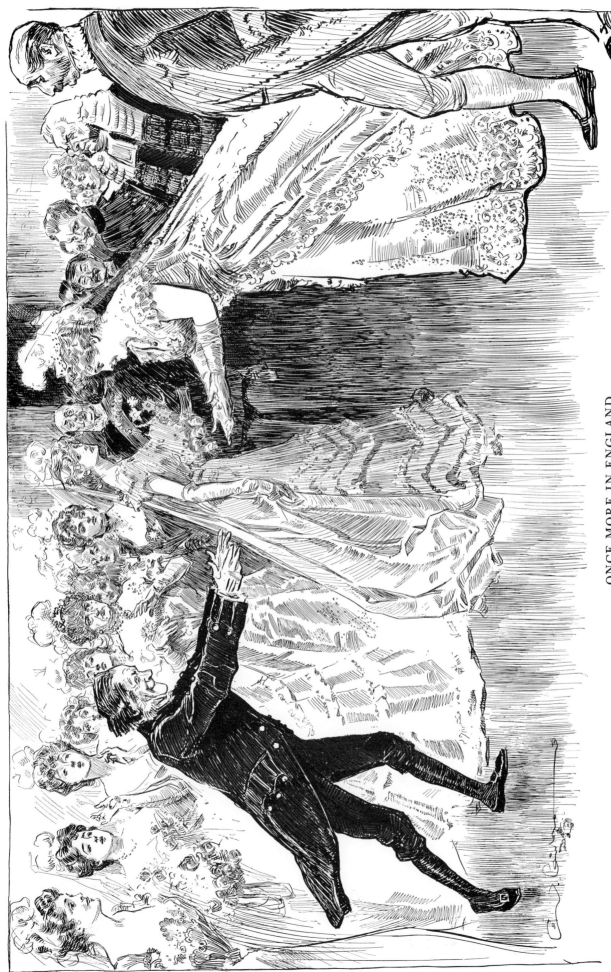

ONCE MORE IN ENGLAND

At the Court of St. James' he meets his old friend Viola, Lady Fitzmaurice.

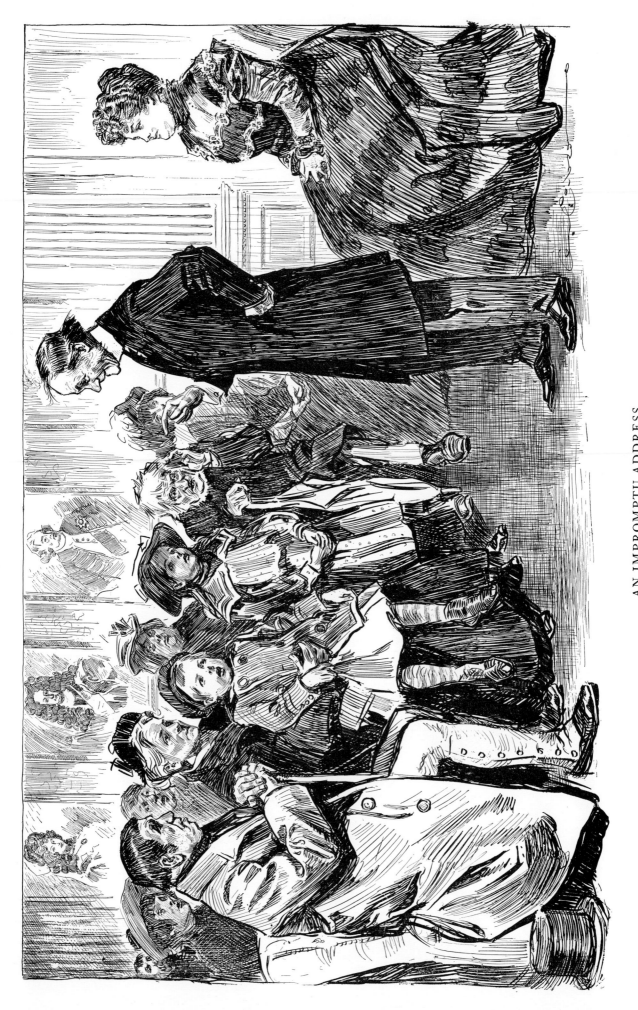

AN IMPROMPTU ADDRESS

Mr. Pipp and his daughters visit Lady Fitzmaurice at Carony Castle. Mr. Pipp meets the tenantry and makes a few remarks.

60

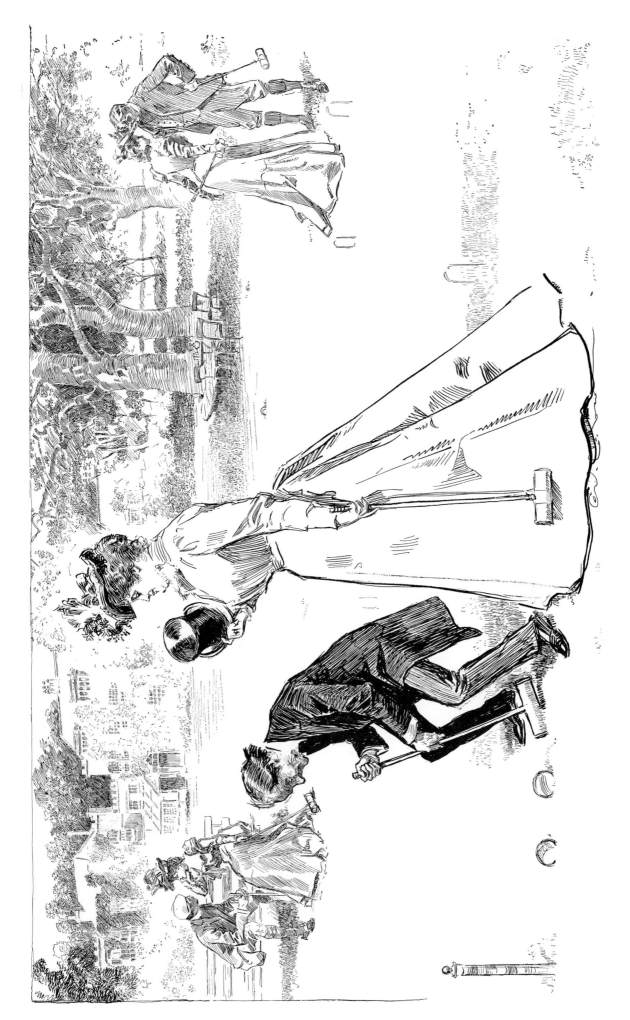

A CRITICAL MOMENT
A match game at Carony Castle.

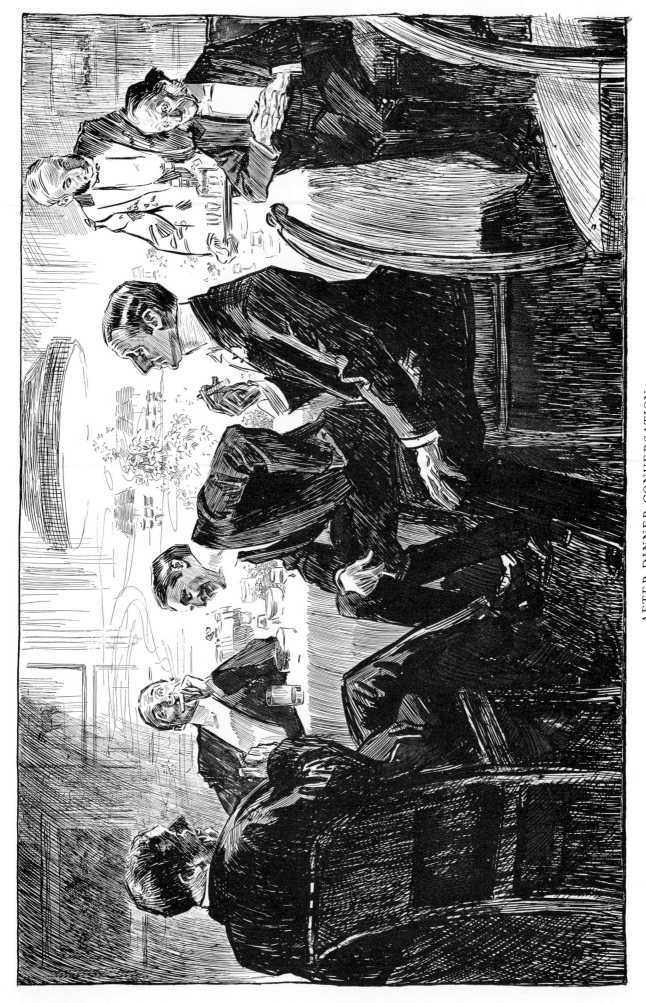

AFTER DINNER CONVERSATION

At Sir Humphrey Plungington's the talk relates chiefly to the approaching derby.

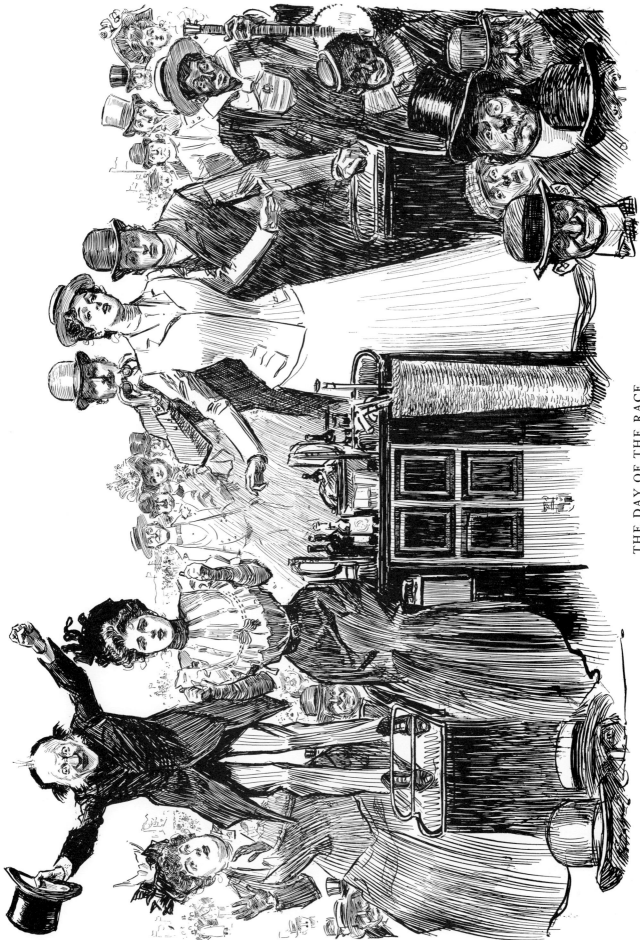

THE DAY OF THE RACE

Mr. Pipp, for the first time in his life, attends the races; he has the good fortune to pick a few winners.

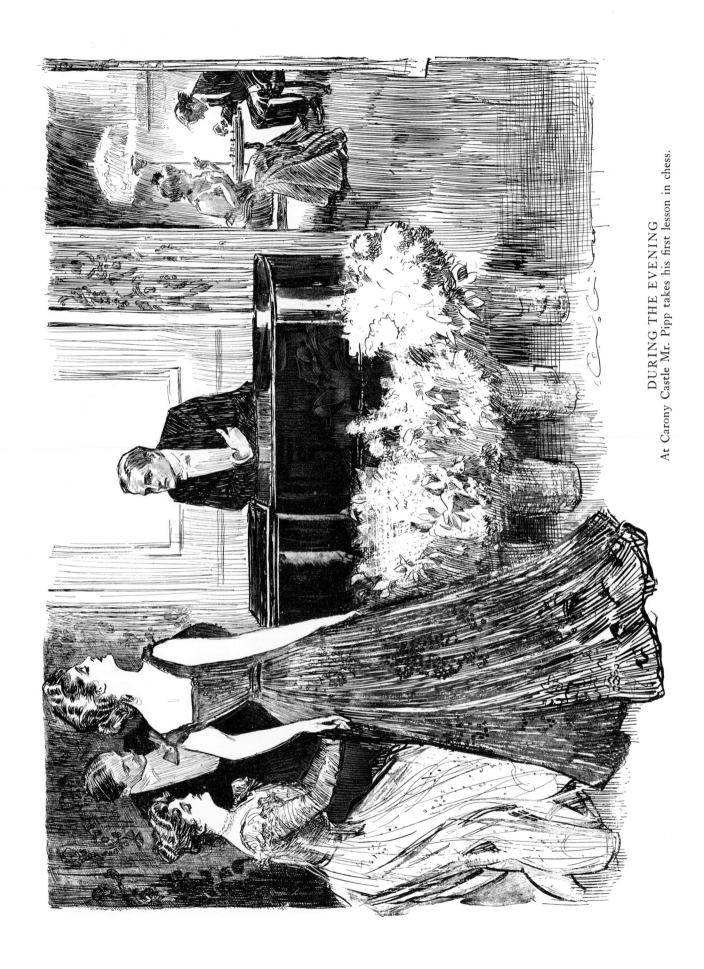

DURING THE EVENING

At Carony Castle Mr. Pipp takes his first lesson in chess.

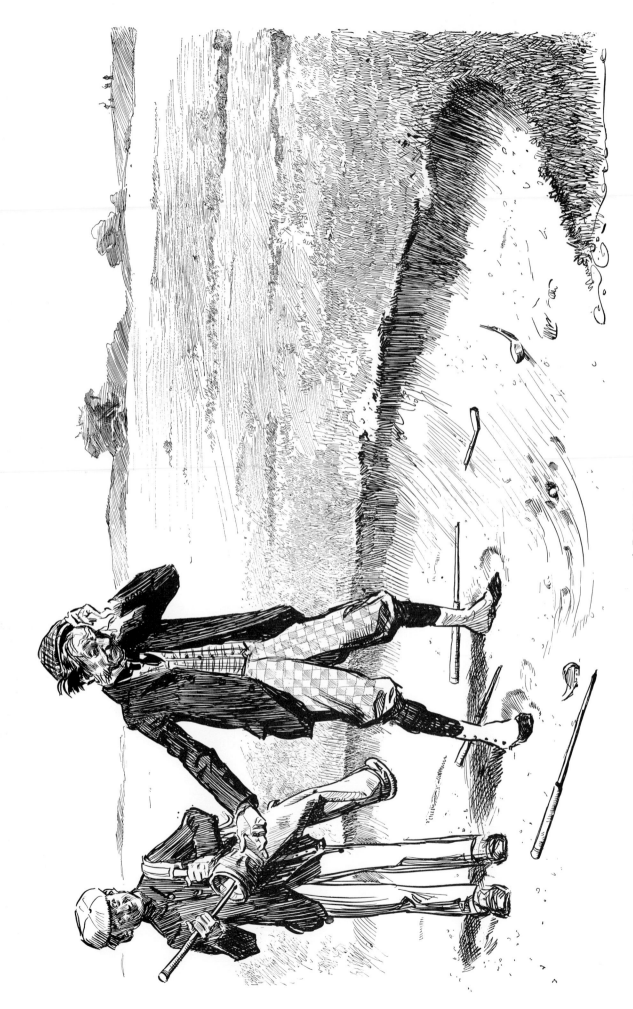

A DAY AT GOLF
At Carony Castle Mr. Pipp tries his hand at golf.

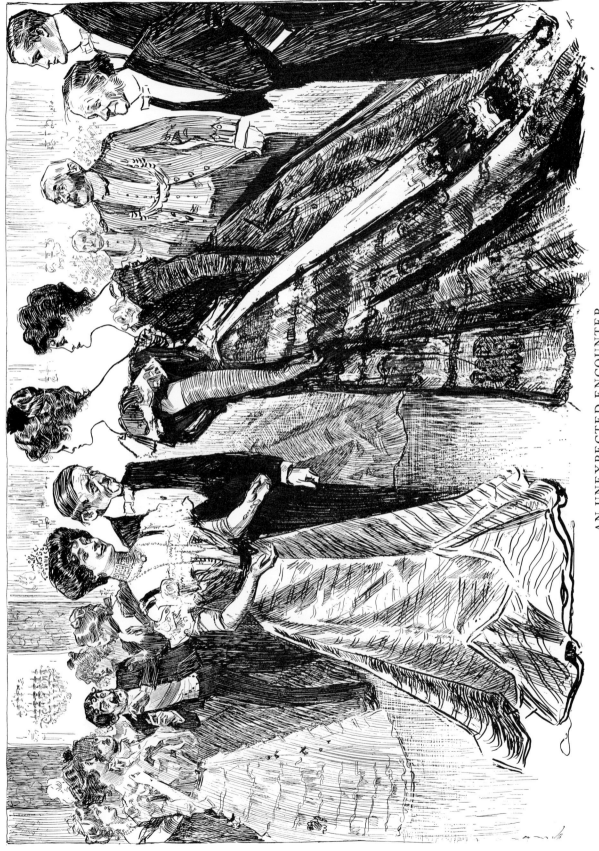

AN UNEXPECTED ENCOUNTER

Mr. Pipp and his daughters, while in London, are invited by an American resident to meet
a distinguished foreigner. This personage proves to be an old acquaintance.

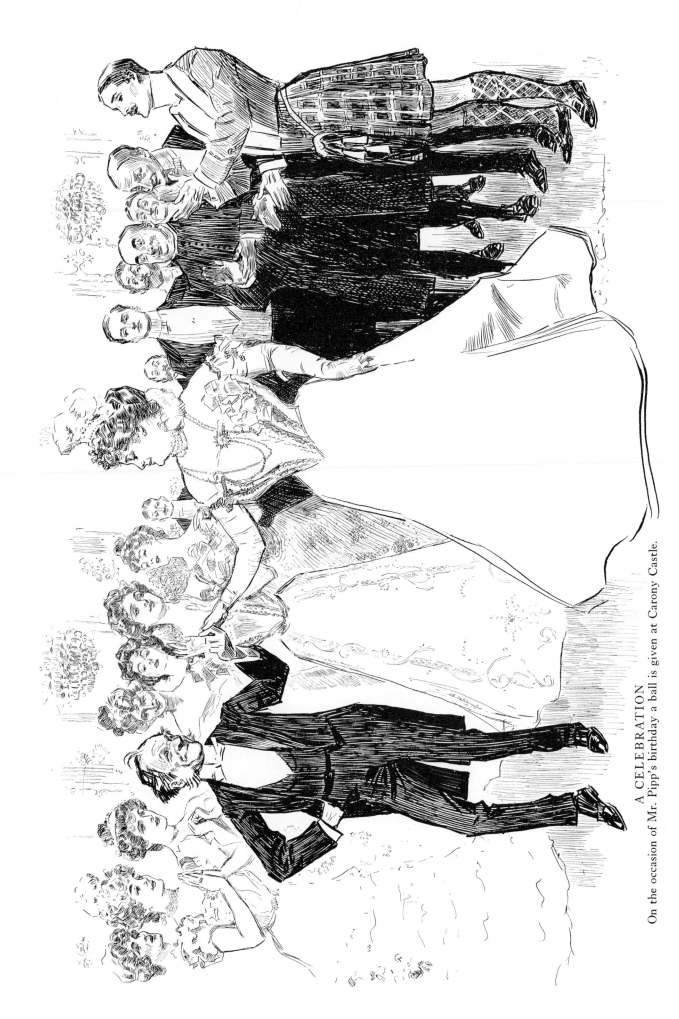

A CELEBRATION

On the occasion of Mr. Pipp's birthday a ball is given at Carony Castle.

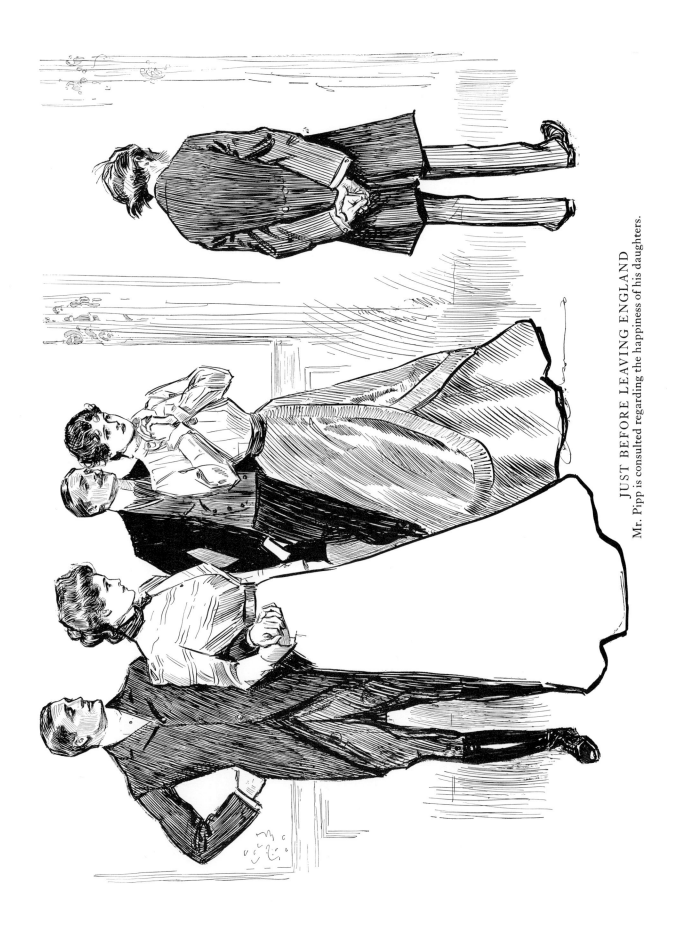

JUST BEFORE LEAVING ENGLAND
Mr. Pipp is consulted regarding the happiness of his daughters.

70

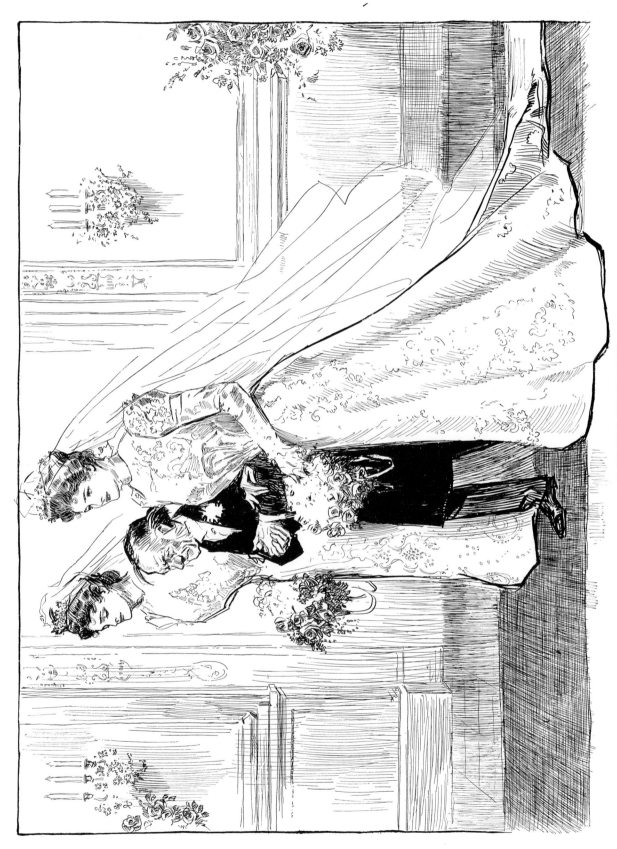

A DOUBLE WEDDING

At which Mr. Pipp makes his greatest sacrifice.

71

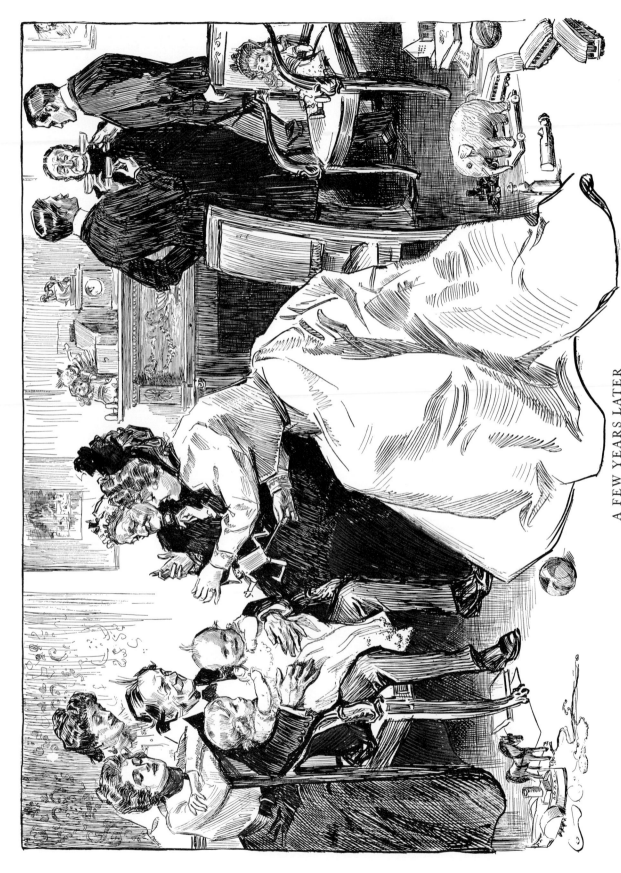

A FEW YEARS LATER

A christening occurs and here we leave Mr. Pipp with the Honorable Viola Fitzmaurice on one knee and Mr. Hiram Pipp Willing on the other. Although the education of Mr. Pipp is still incomplete, he has learned that he has not lived in vain.

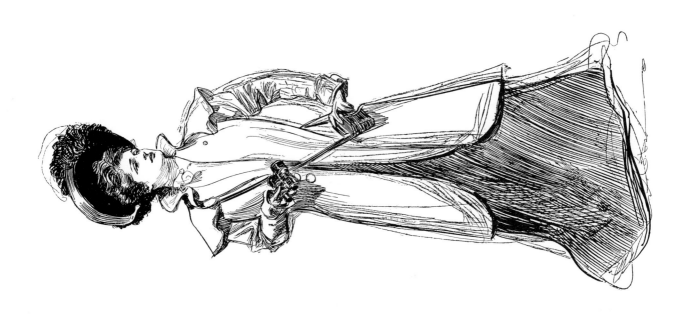

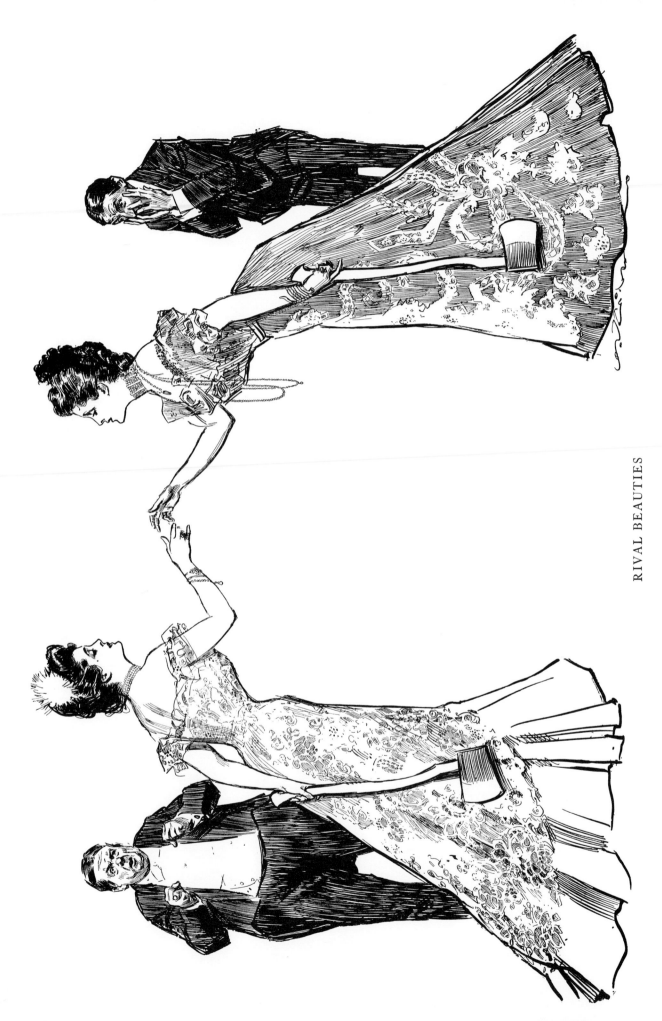

RIVAL BEAUTIES

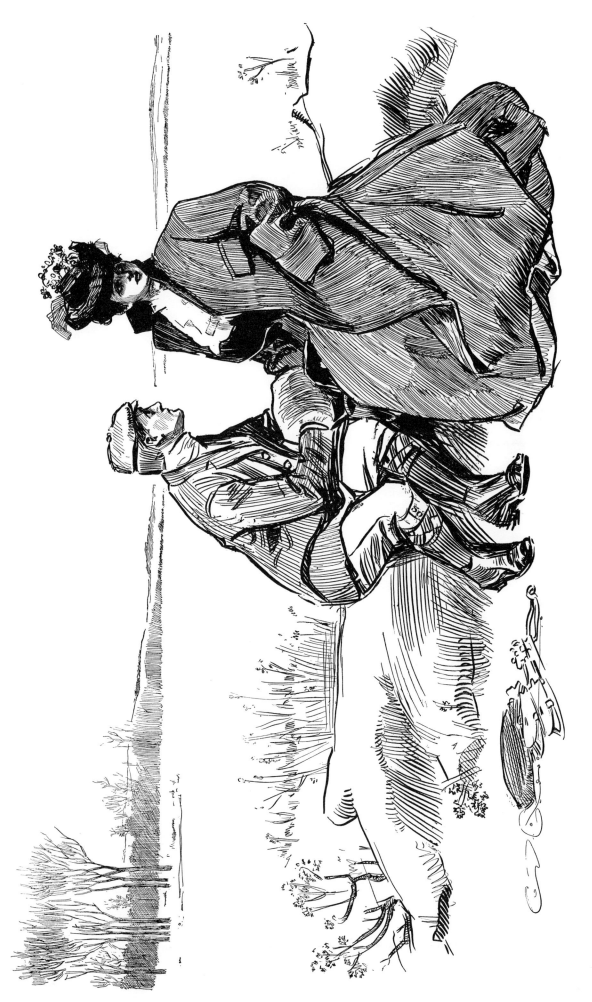

MELTING

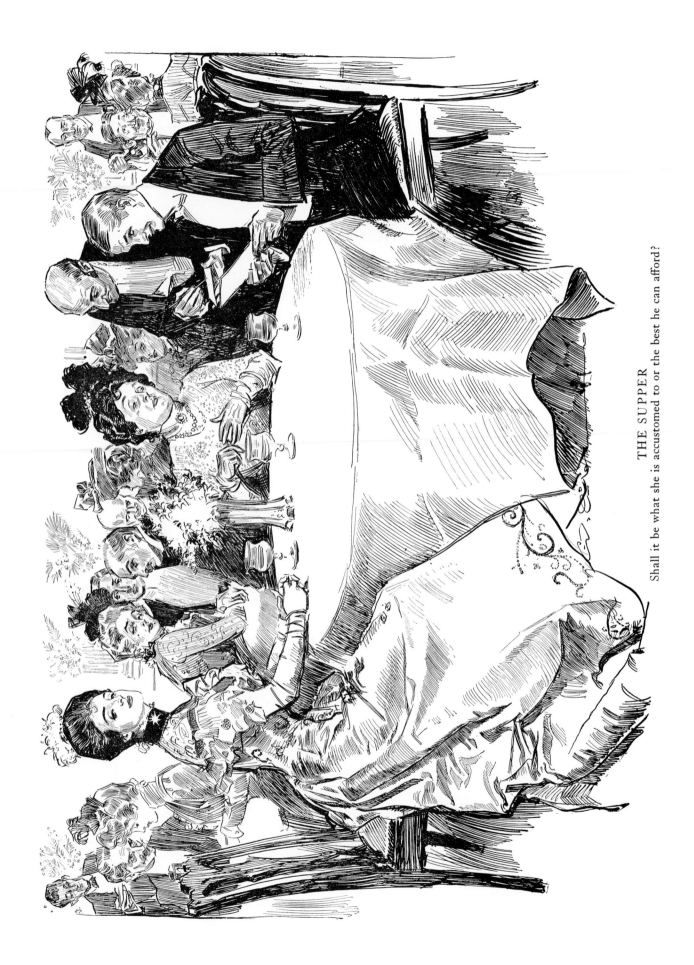

THE SUPPER

Shall it be what she is accustomed to or the best he can afford?

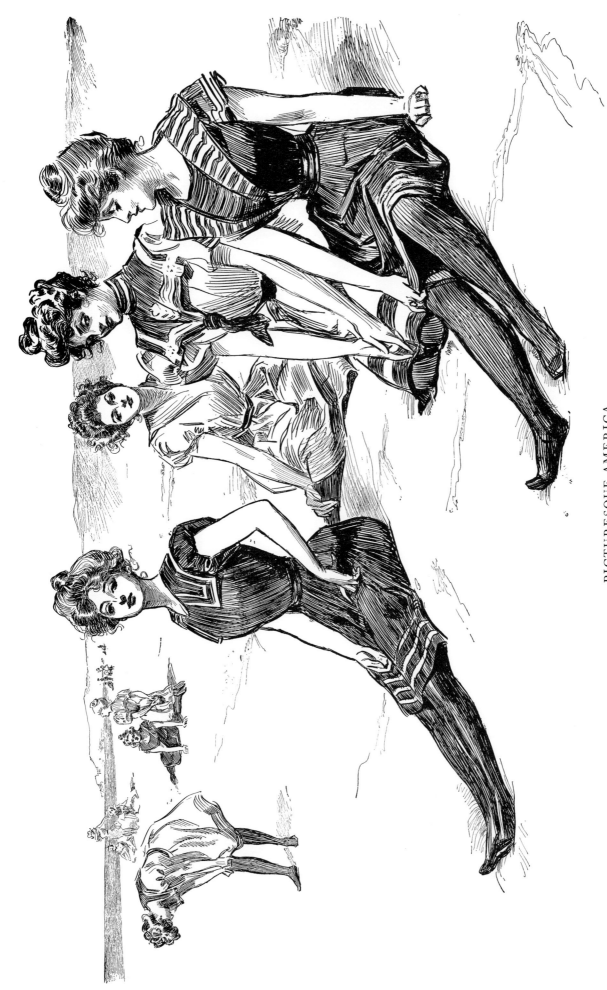

PICTURESQUE AMERICA
Anywhere along the coast.

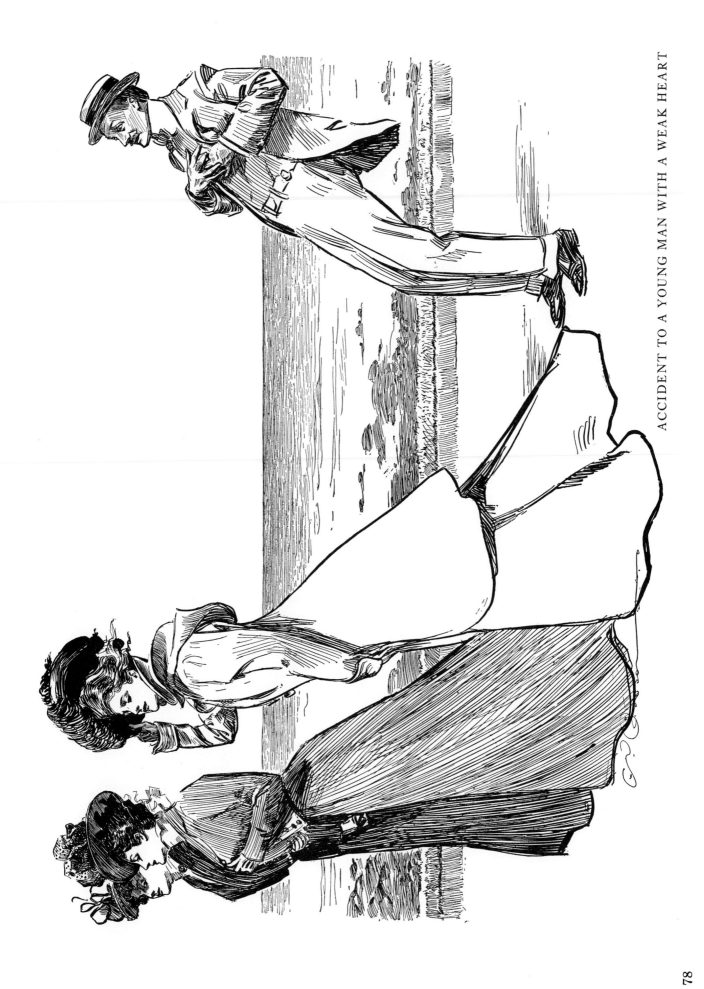

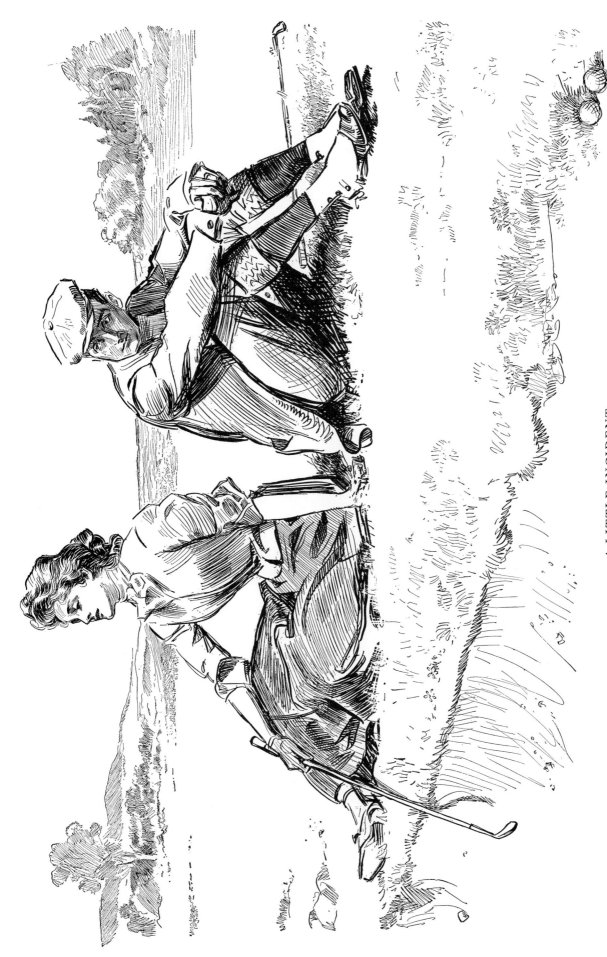

A LITTLE INCIDENT

Showing that even inanimate objects can enter into the spirit of the game.

THE RACE IS NOT ALWAYS TO THE BEAUTIFUL

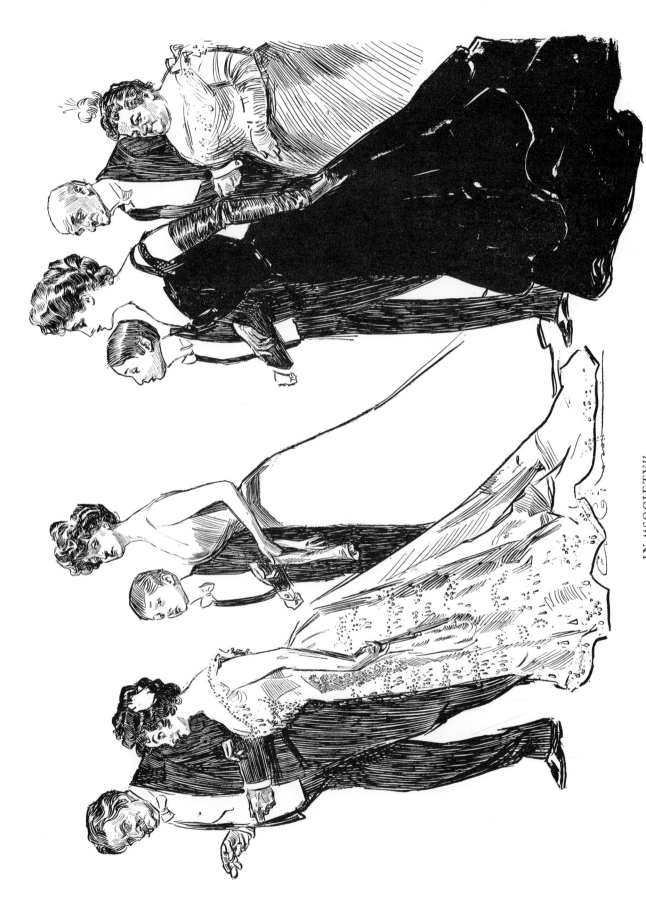

IN "SOCIETY"

Do we see so much of old age and youth because the middle-aged men have something better to do?

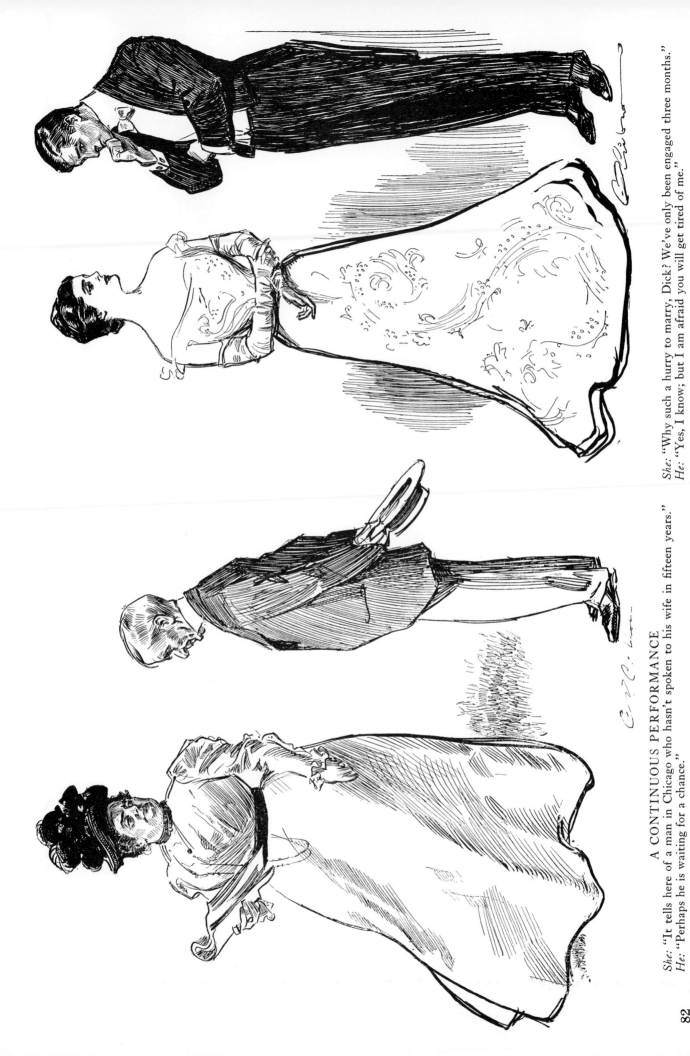

A CONTINUOUS PERFORMANCE

She: "It tells here of a man in Chicago who hasn't spoken to his wife in fifteen years."
He: "Perhaps he is waiting for a chance."

She: "Why such a hurry to marry, Dick? We've only been engaged three months."
He: "Yes, I know; but I am afraid you will get tired of me."

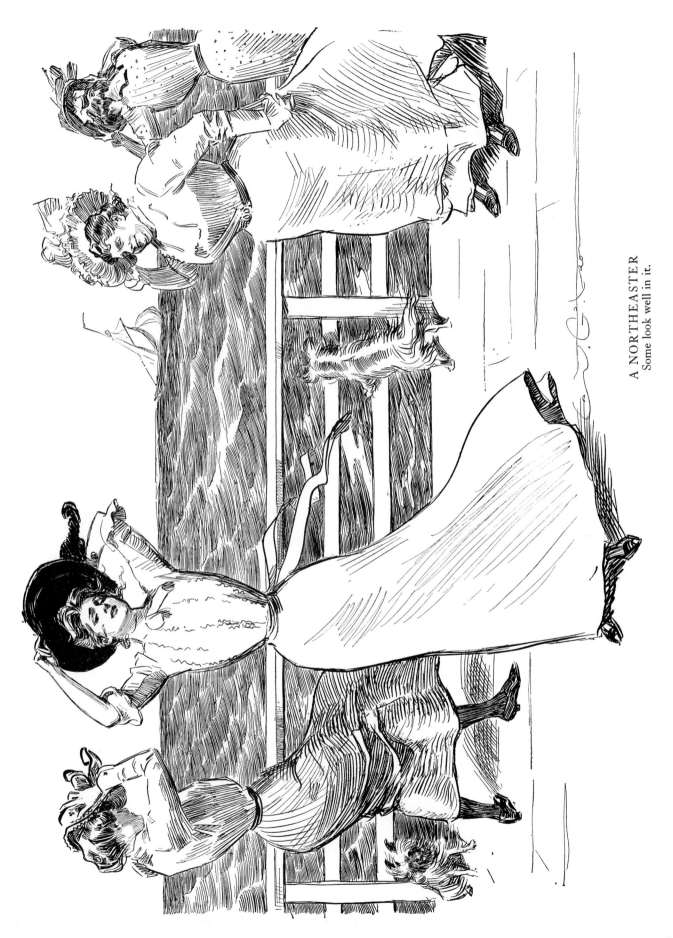

A NORTHEASTER
Some look well in it.

83

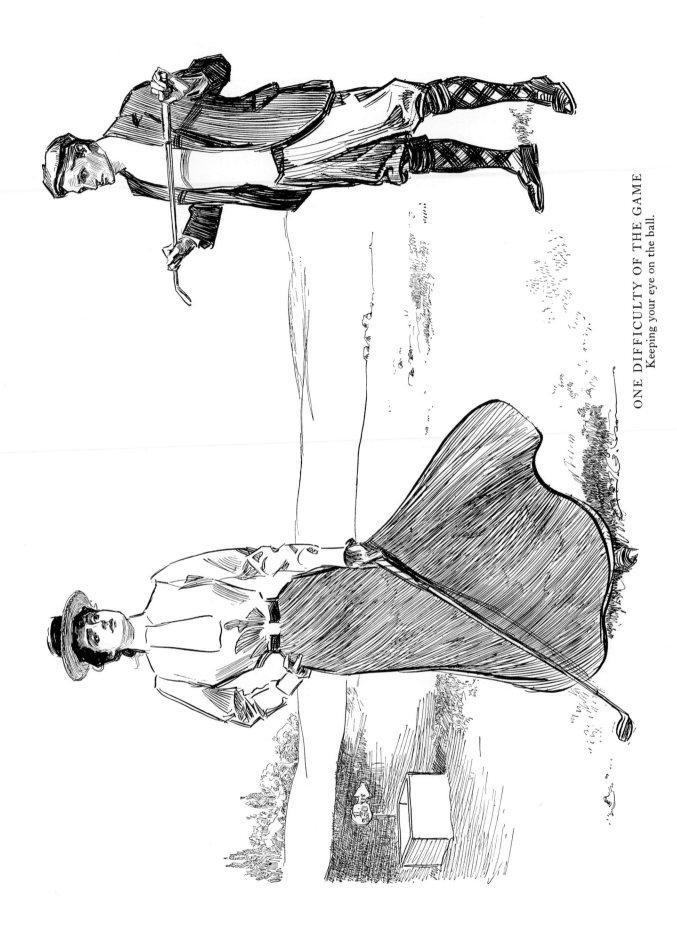

ONE DIFFICULTY OF THE GAME
Keeping your eye on the ball.

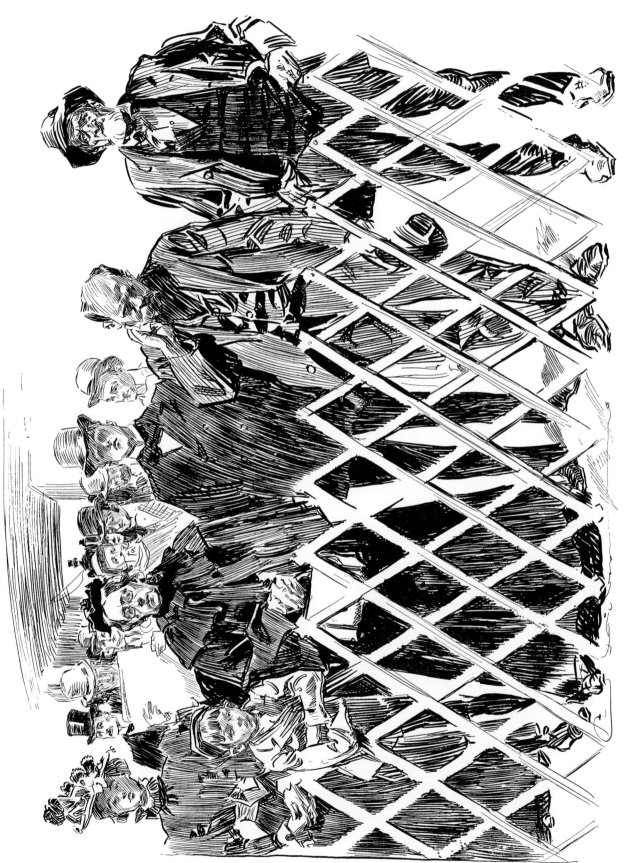

ON THE FERRY

"ON THE SIDEWALKS OF NEW YORK"

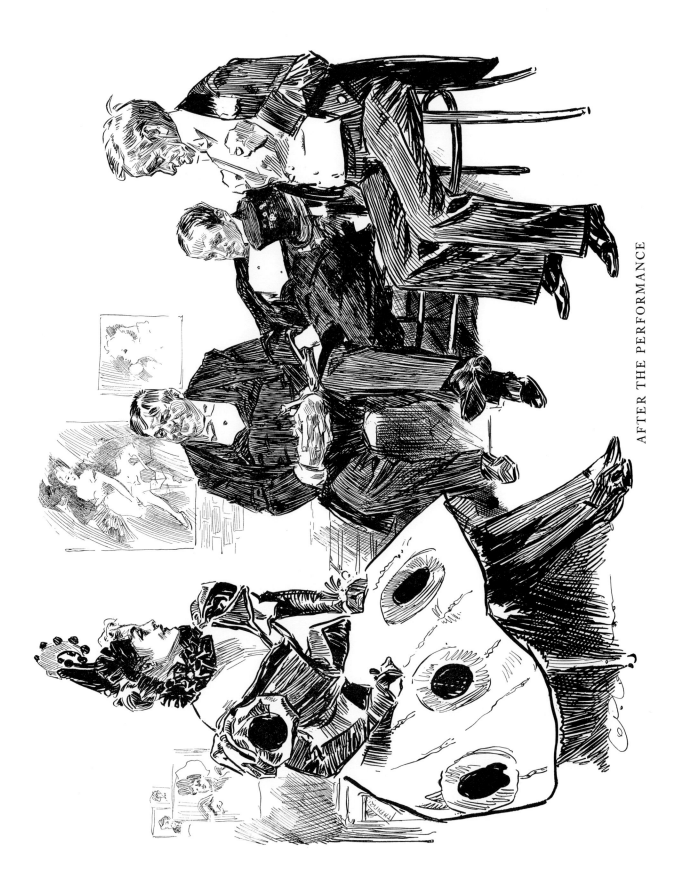

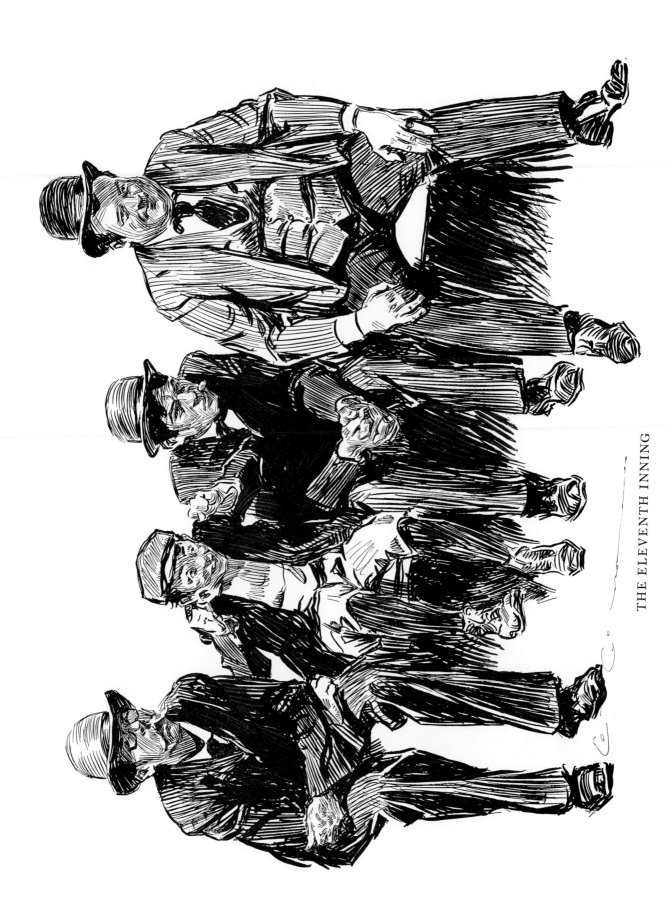

THE ELEVENTH INNING

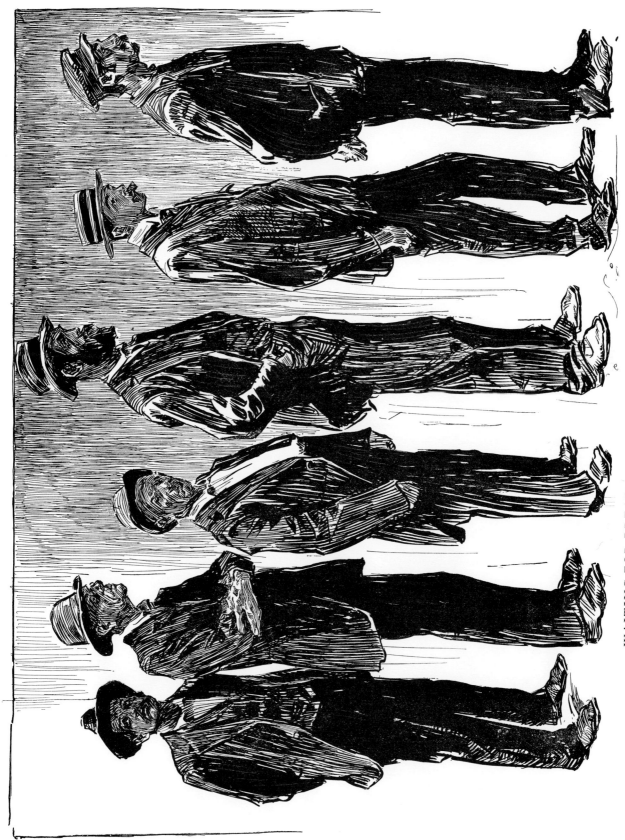

WAITING FOR BREAD

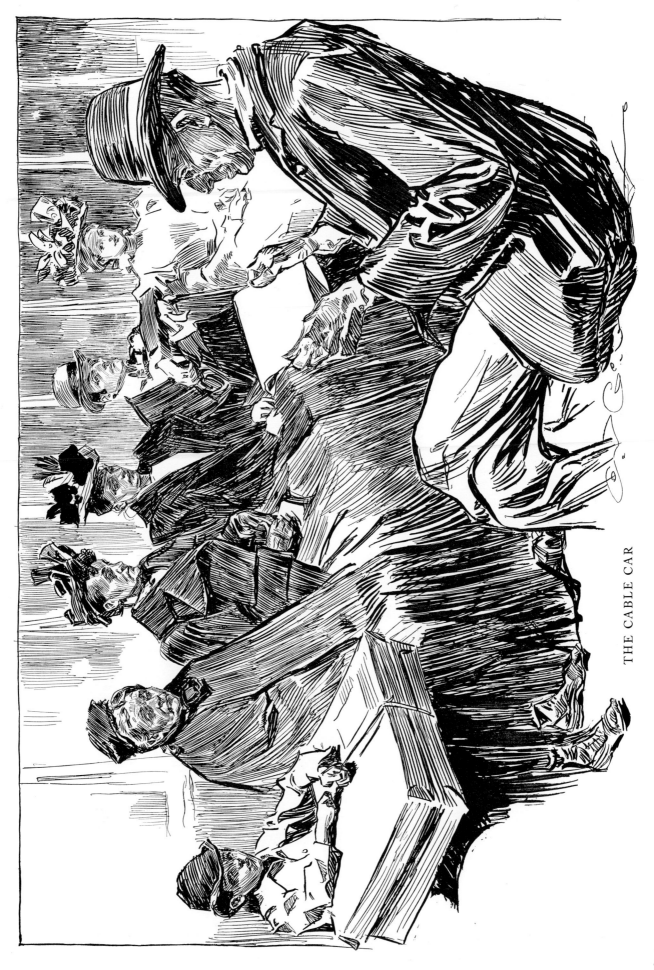

THE CABLE CAR

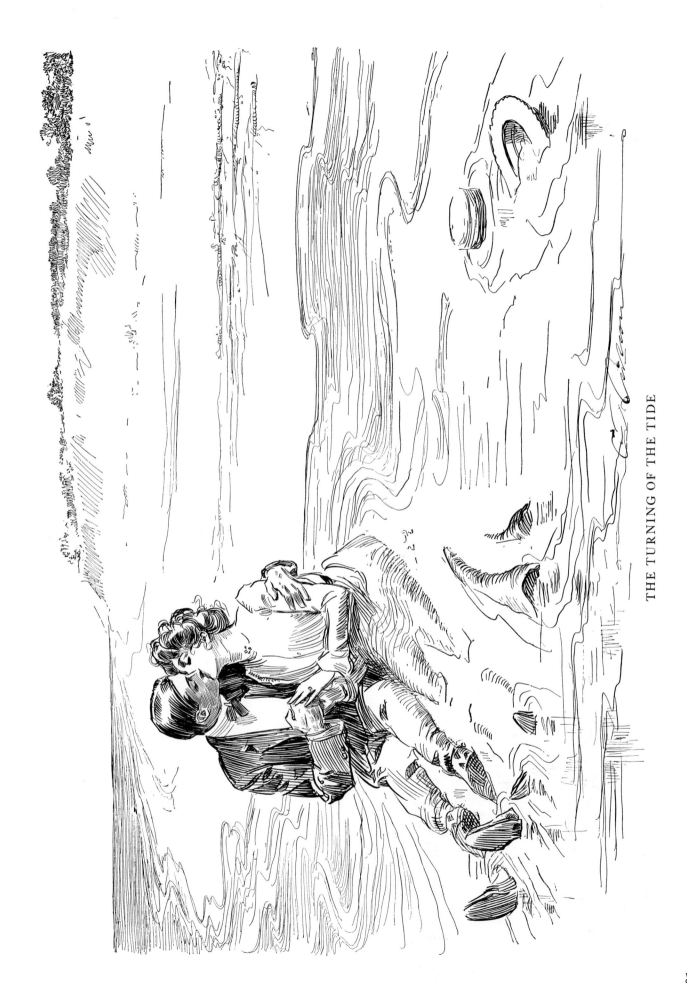

THE TURNING OF THE TIDE

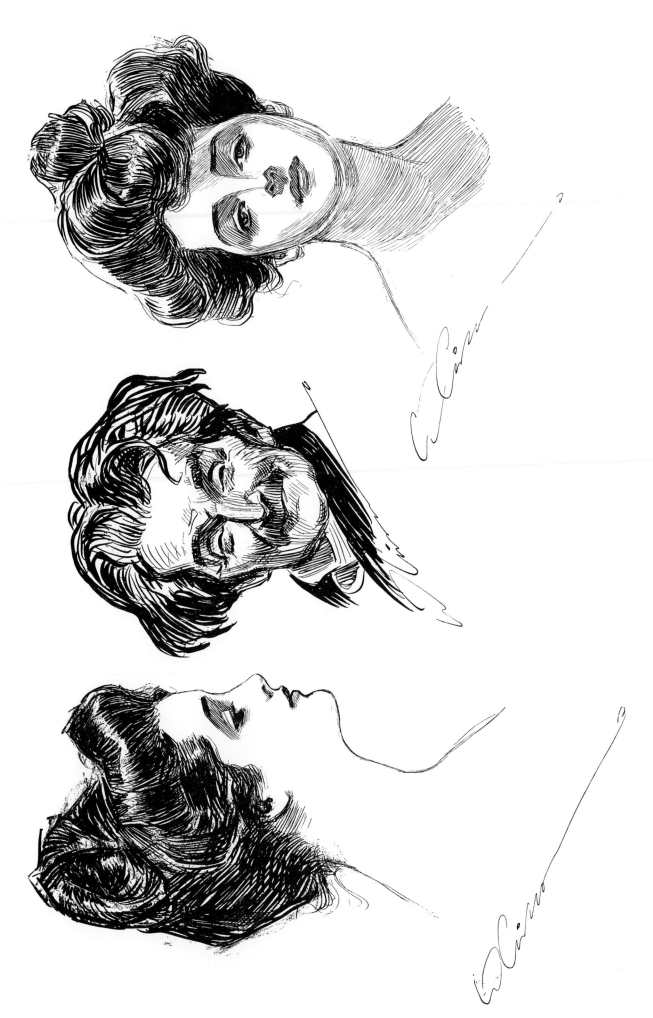

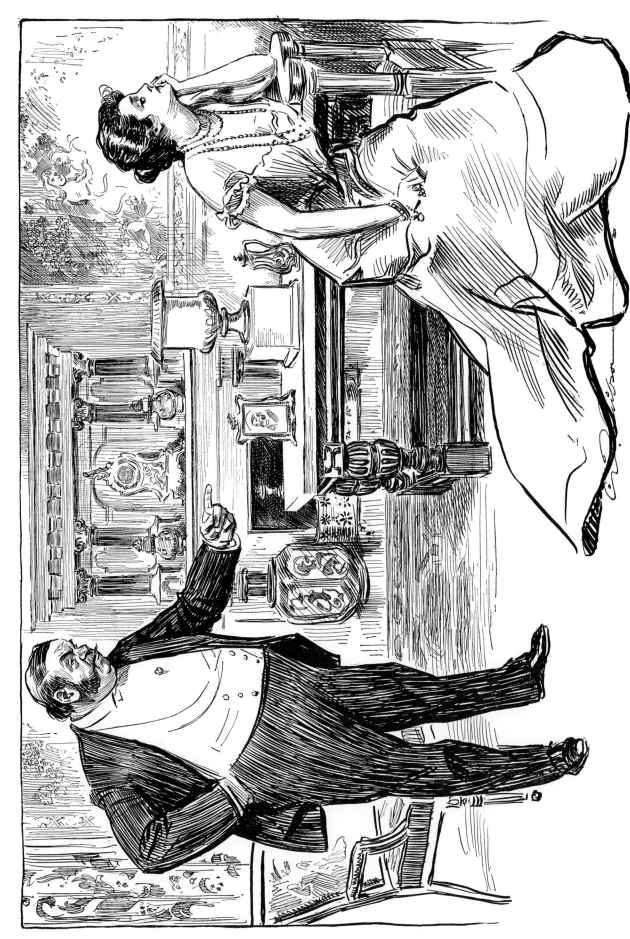

EVERYTHING IN THE WORLD THAT MONEY CAN BUY

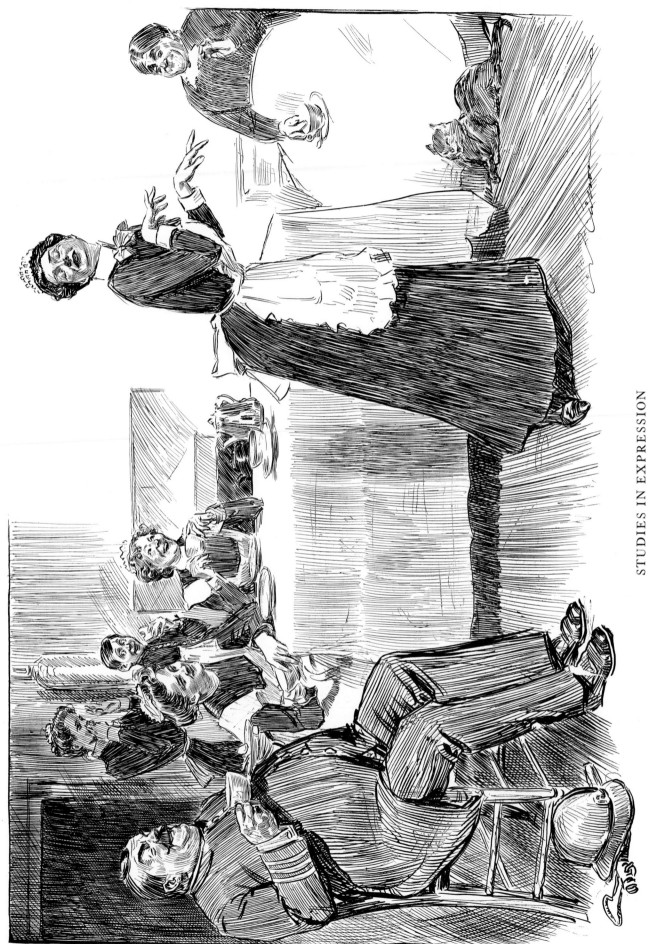

STUDIES IN EXPRESSION
An imitation of the lady of the house.

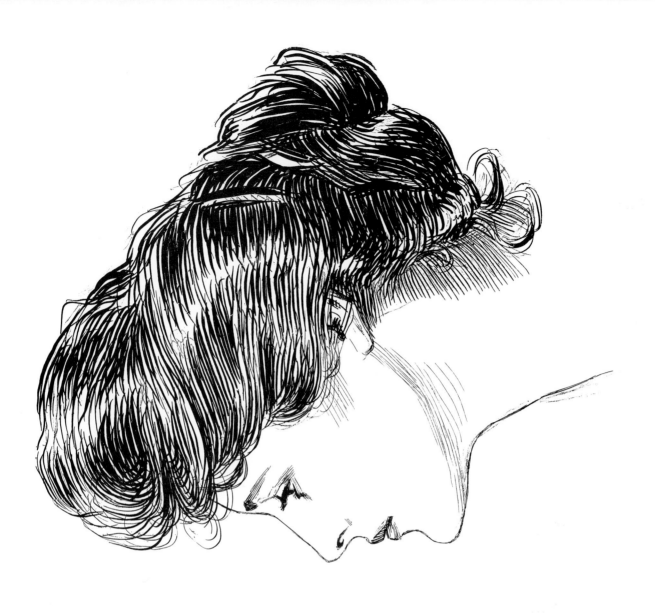

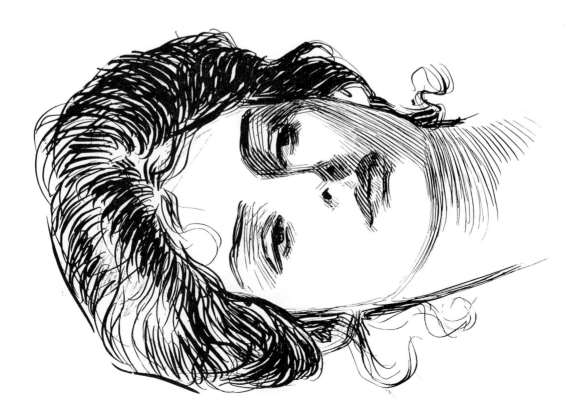

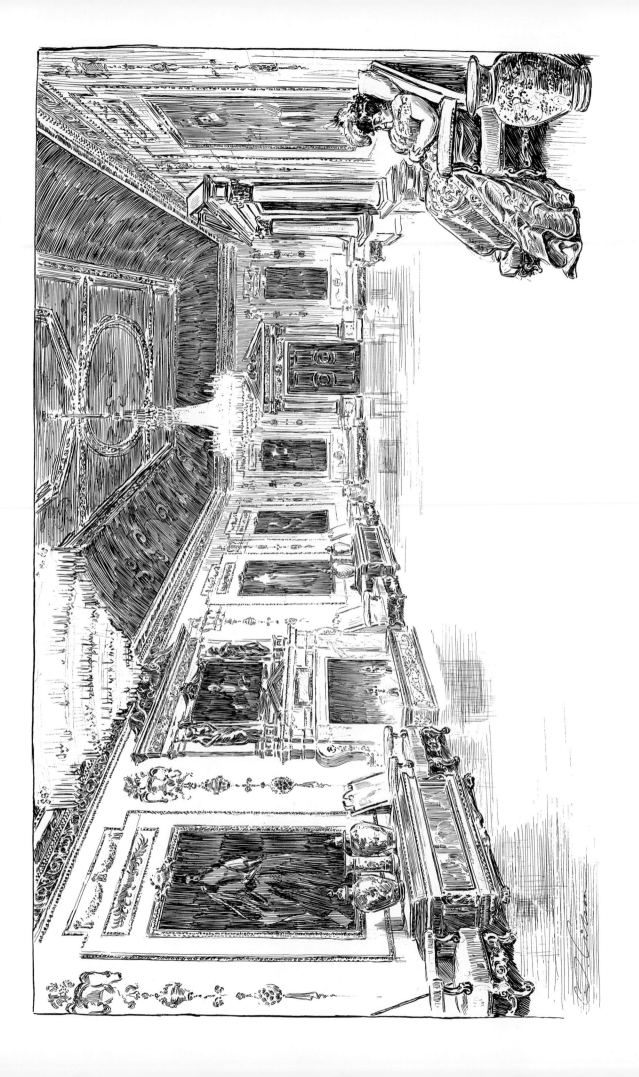

MRS. STEELE POOLE'S HOUSEWARMING

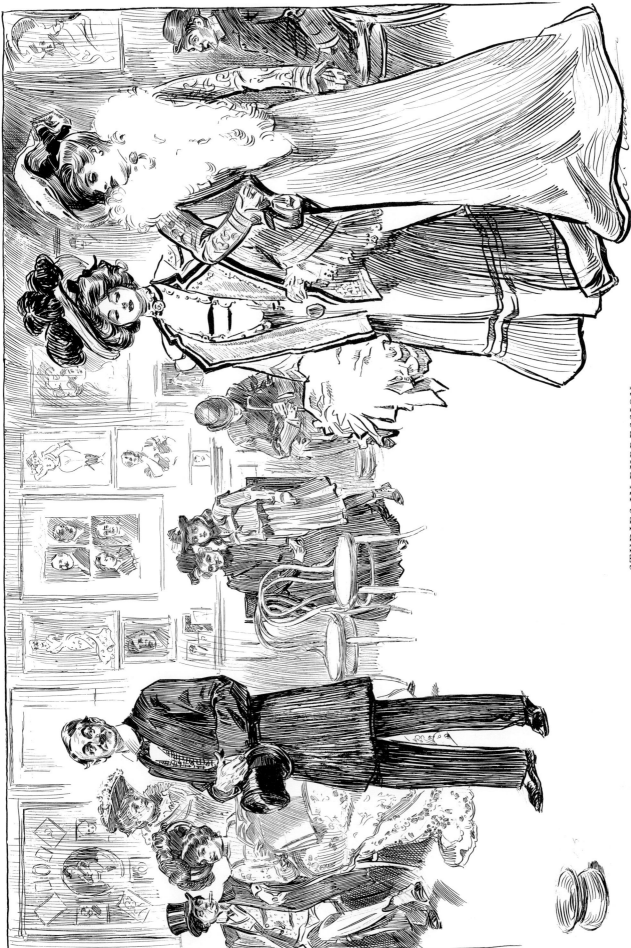

STUDIES IN EXPRESSION
At a dramatic agency.

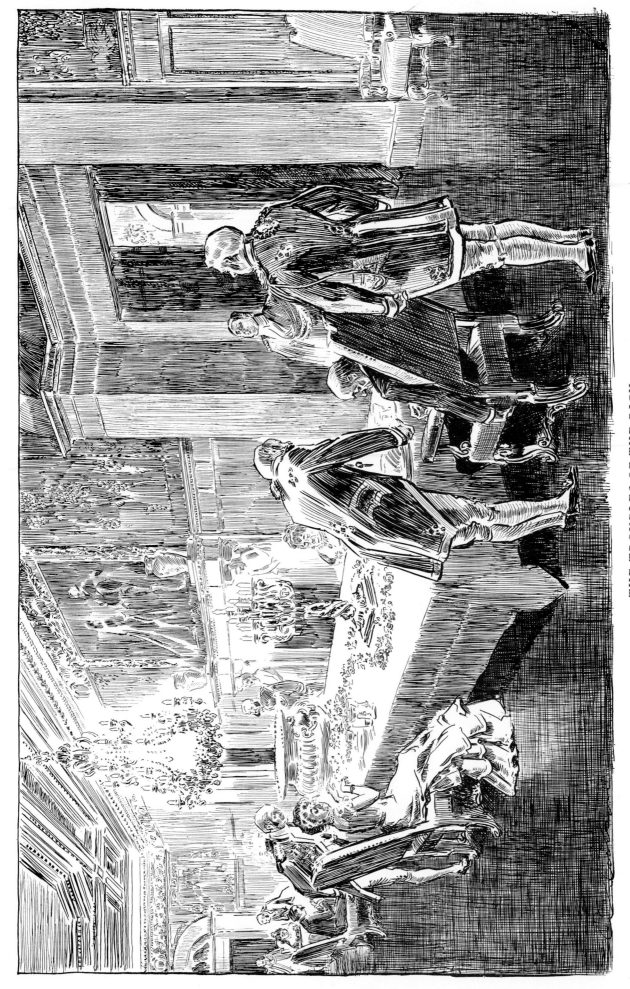

THE TROUBLES OF THE RICH

At the last moment, several who were invited send their regrets.

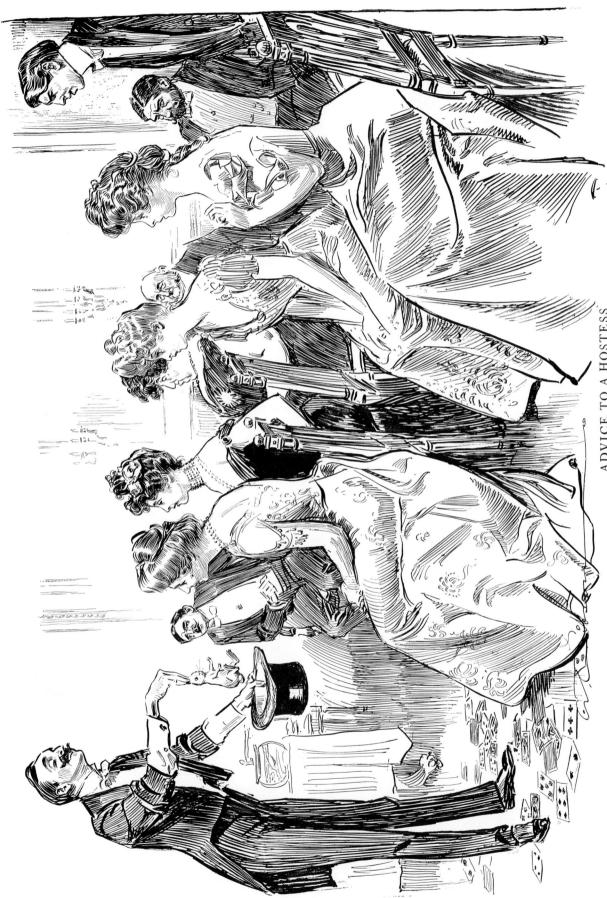

ADVICE TO A HOSTESS

Keep your entertainment within the mental grasp of your guests.

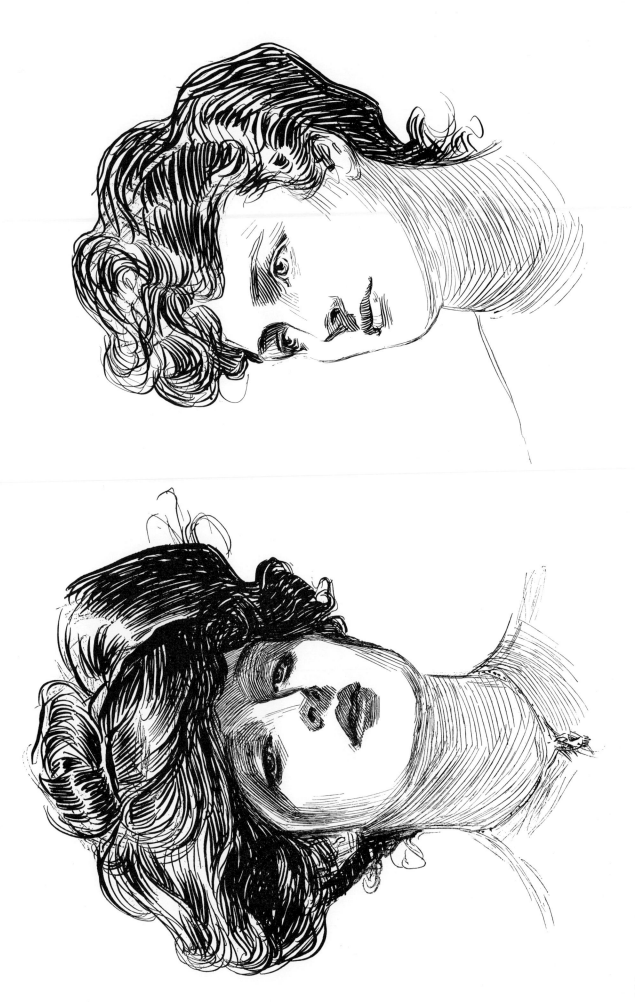

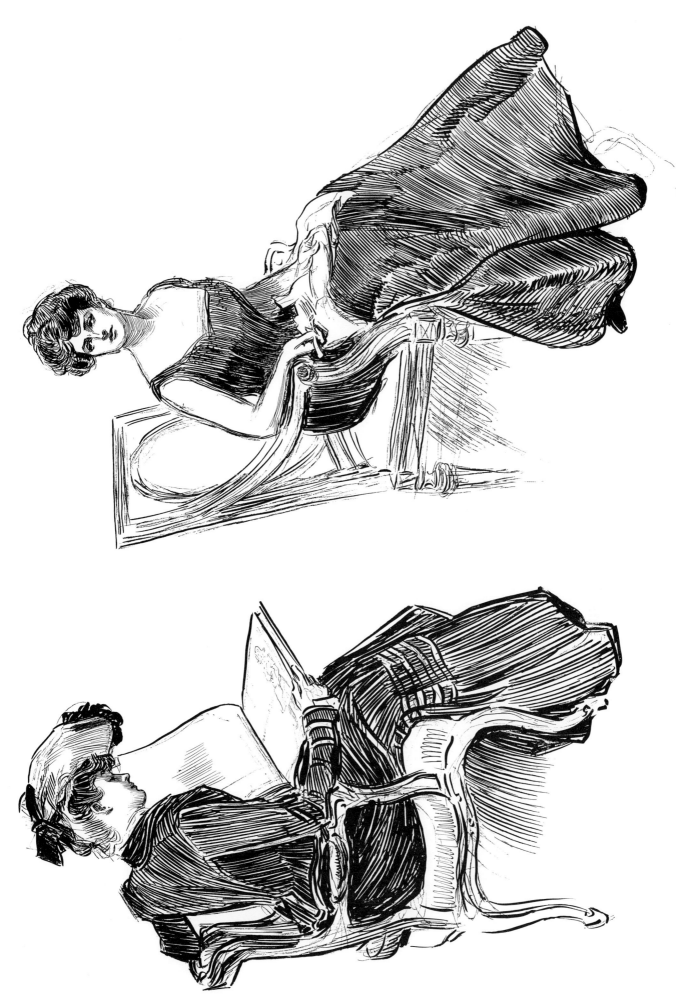

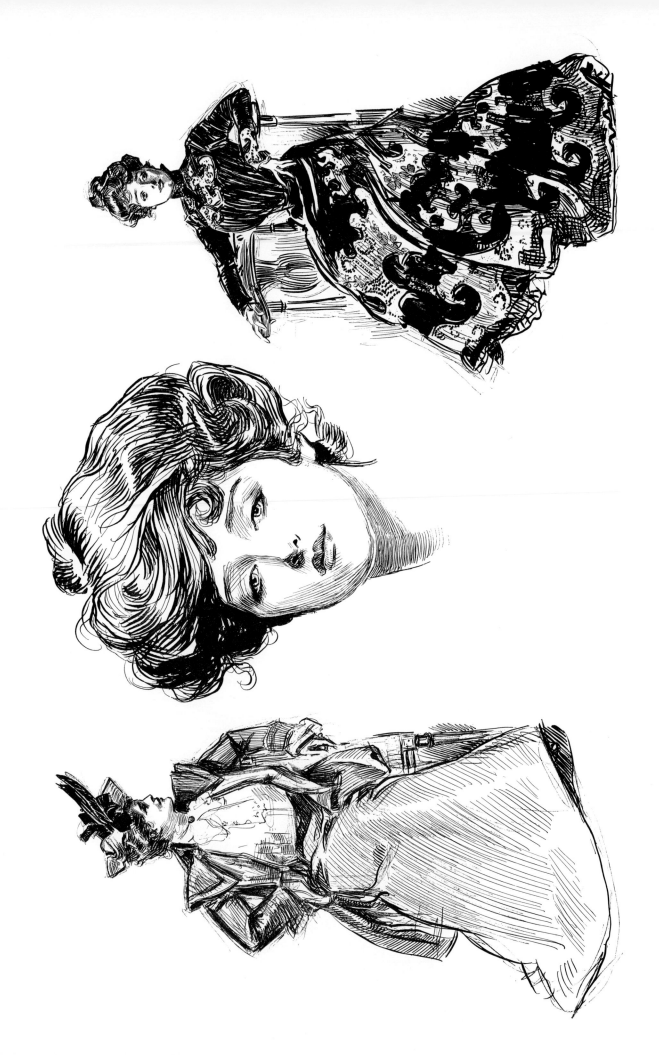

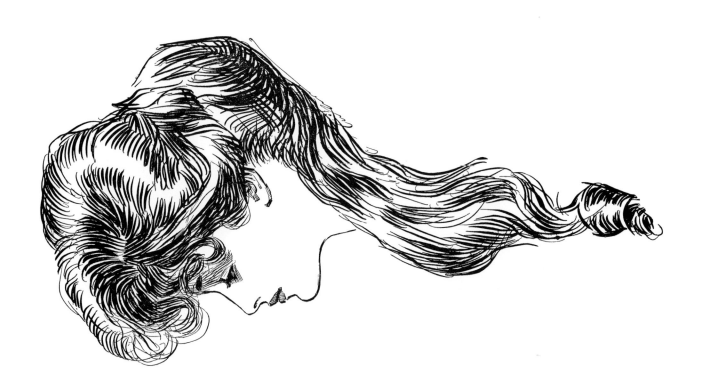

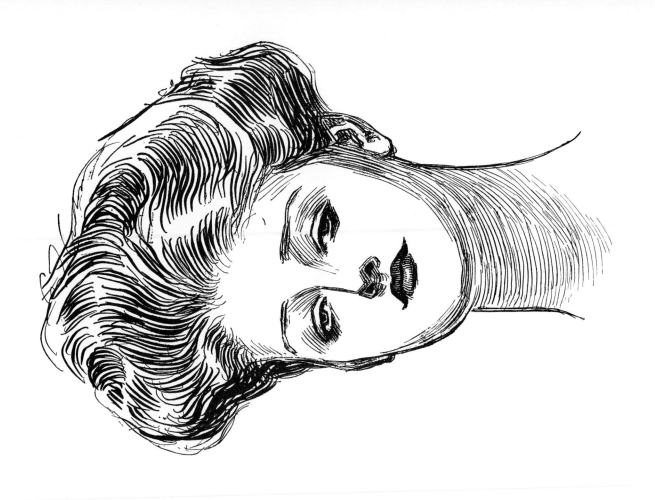

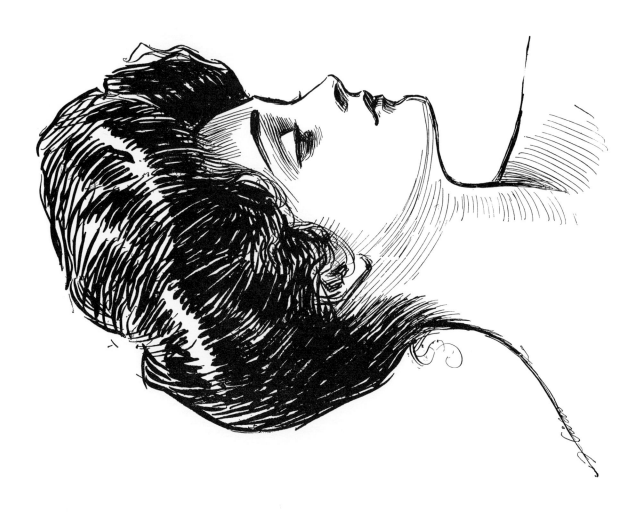

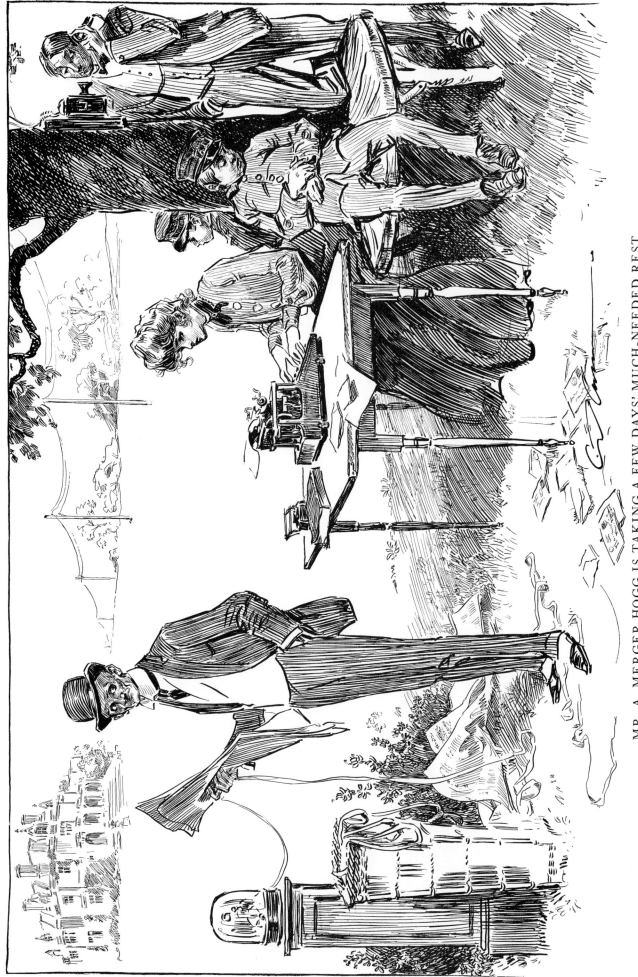

MR. A. MERGER HOGG IS TAKING A FEW DAYS' MUCH-NEEDED REST
AT HIS COUNTRY HOME

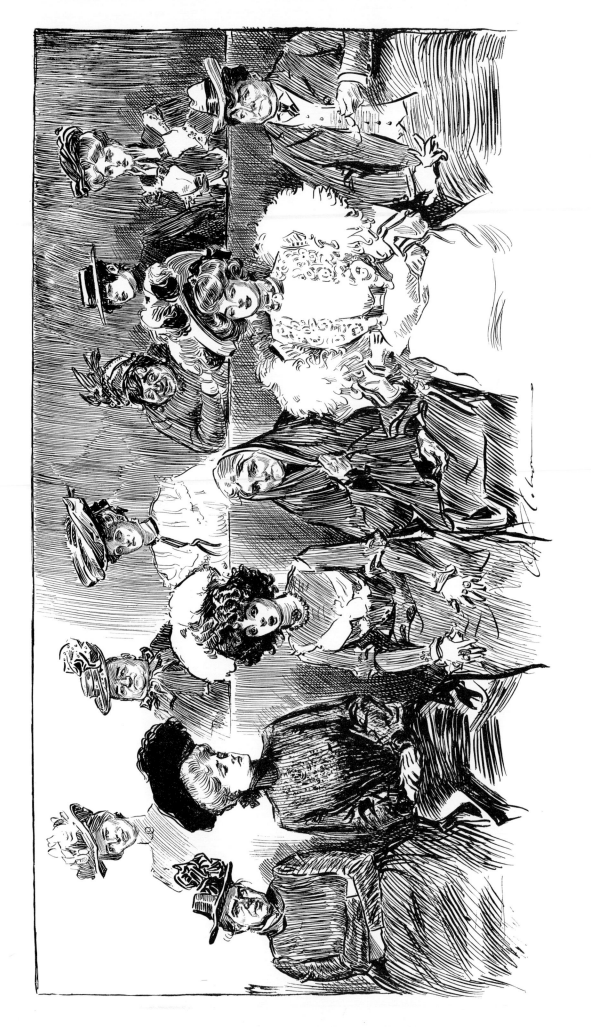

STUDIES IN EXPRESSION
When women are jurors.

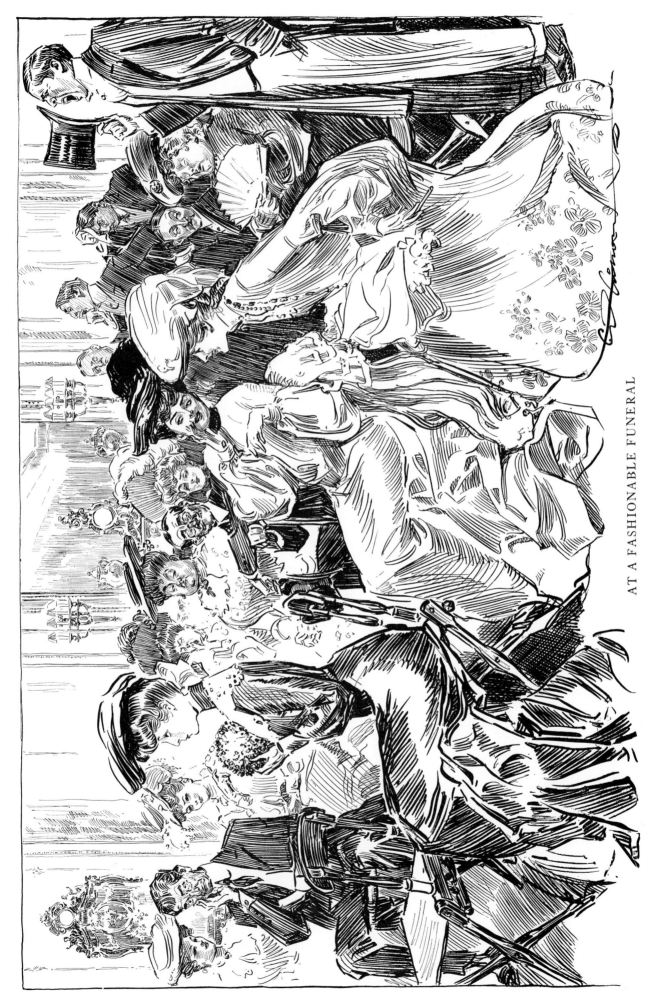

AT A FASHIONABLE FUNERAL

SOME OF THE CARETAKER'S RELATIONS

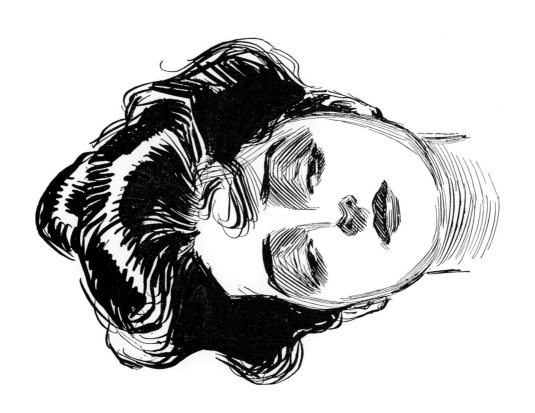

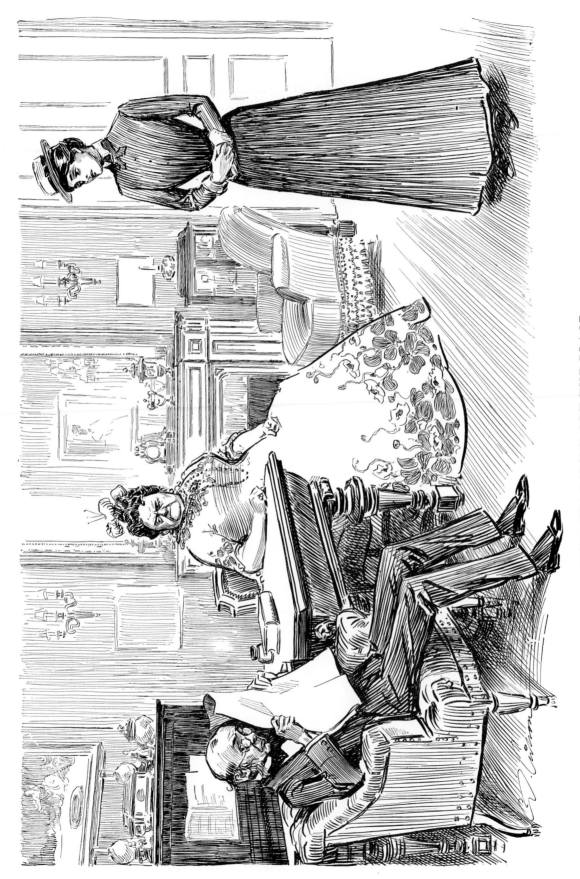

WHY SHE DIDN'T GET THE PLACE

The man behind the paper ventured the opinion that she might do.

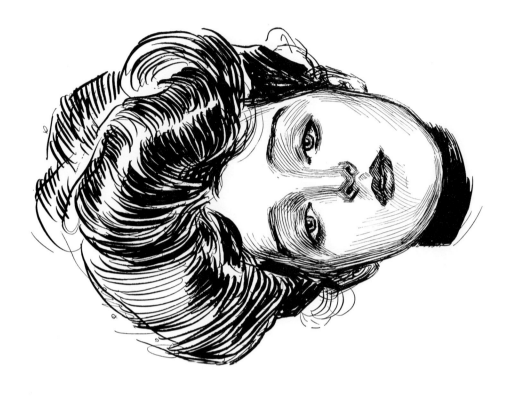

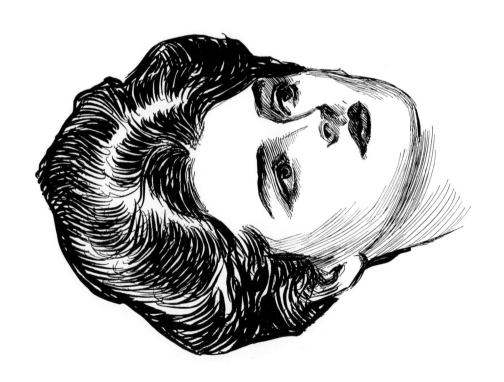

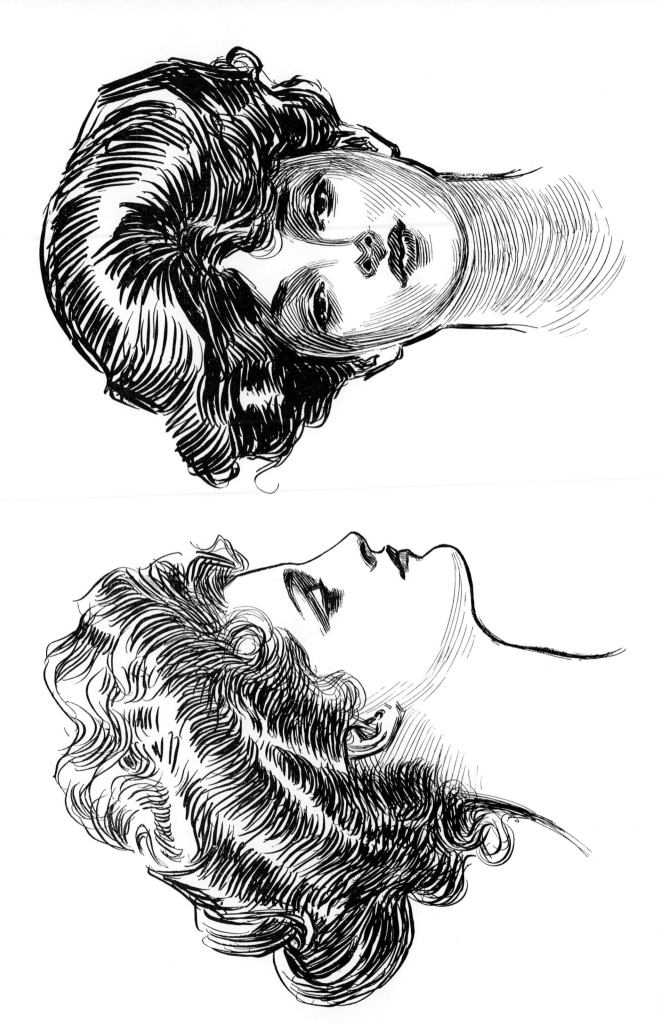

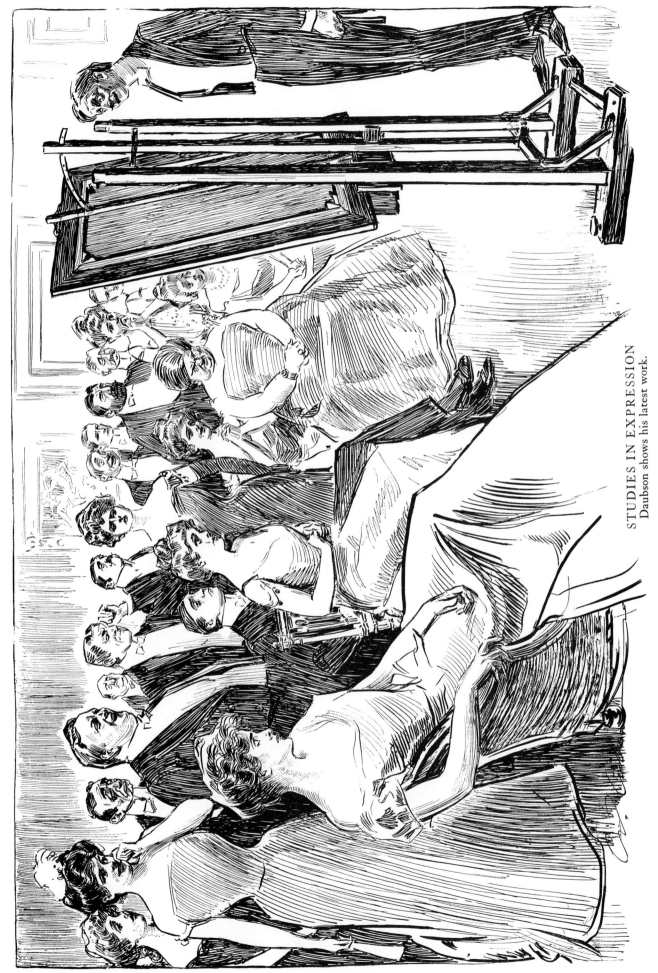

STUDIES IN EXPRESSION
Daubson shows his latest work.

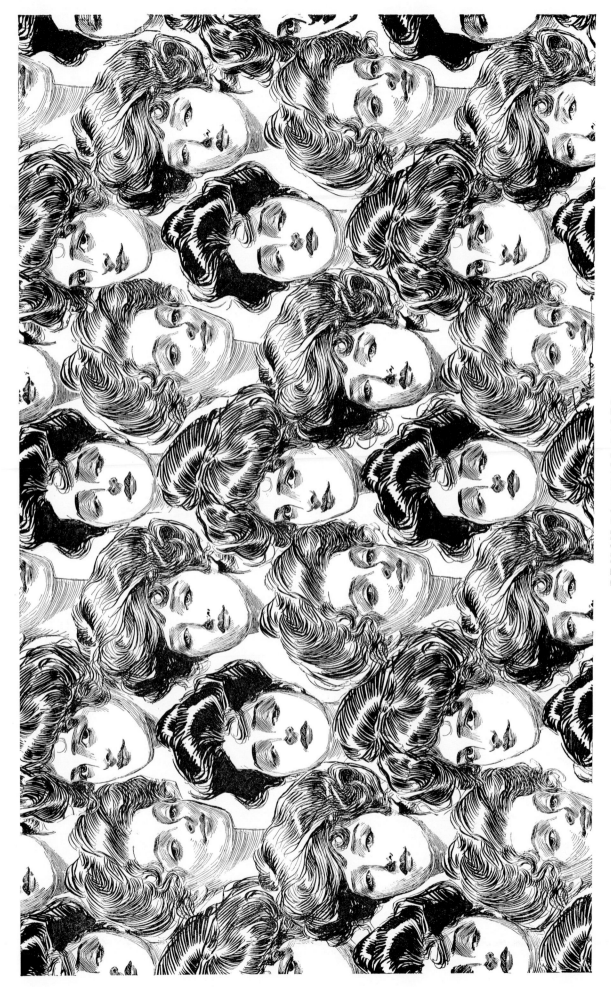

DESIGN FOR WALL PAPER
Suitable for a bachelor apartment.

114

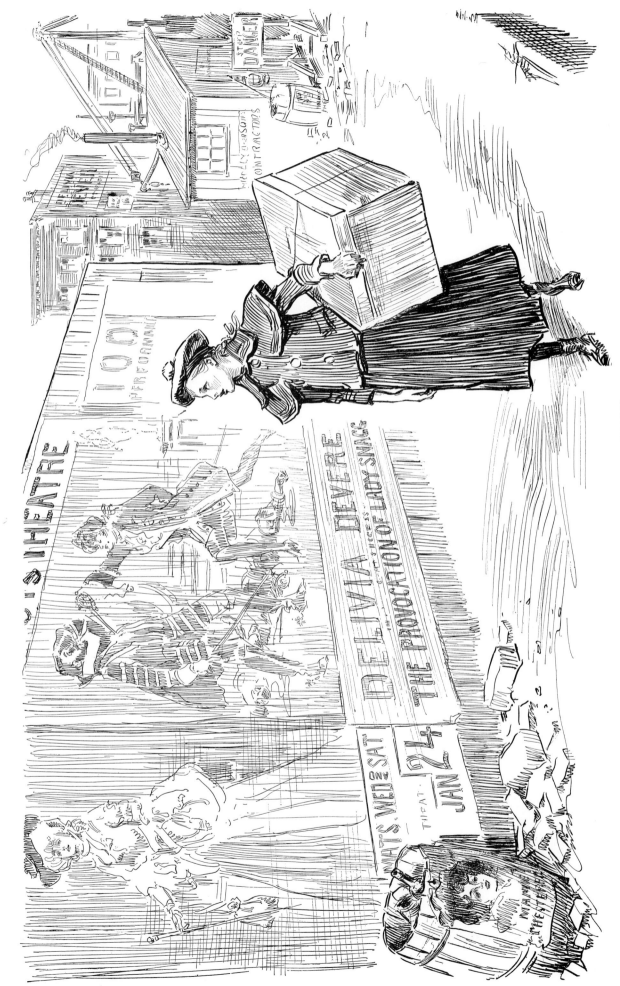

THE SEED OF AMBITION

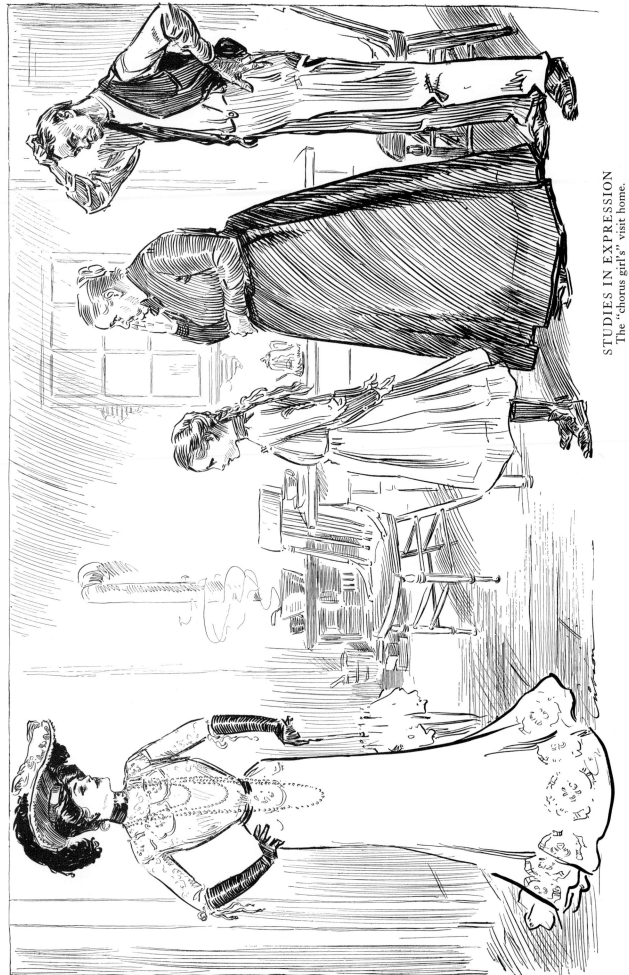

STUDIES IN EXPRESSION
The "chorus girl's" visit home.

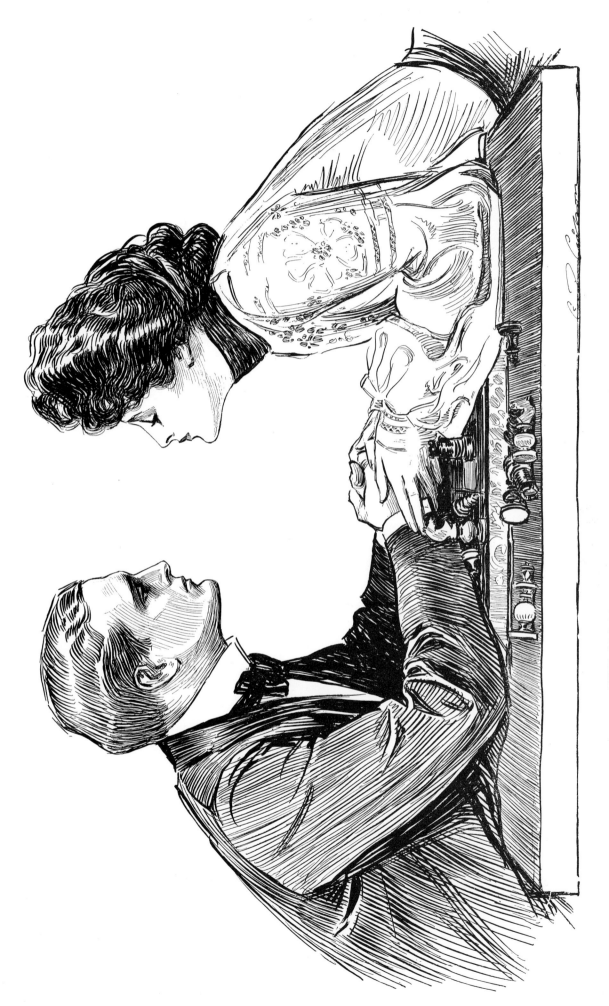

THE GREATEST GAME IN THE WORLD—HIS MOVE

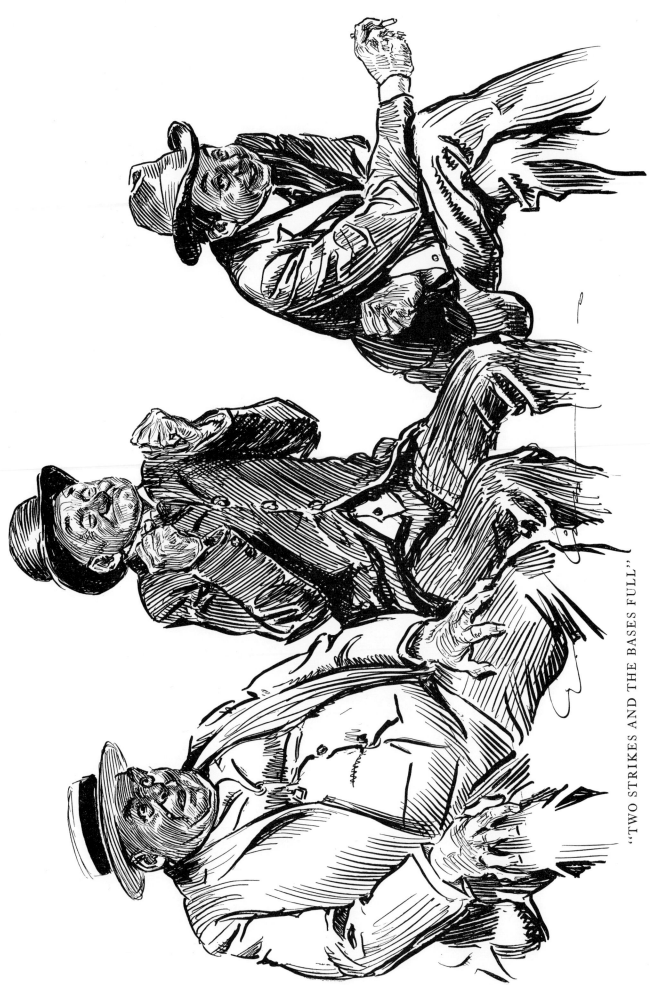

"TWO STRIKES AND THE BASES FULL"

"FANNED OUT"

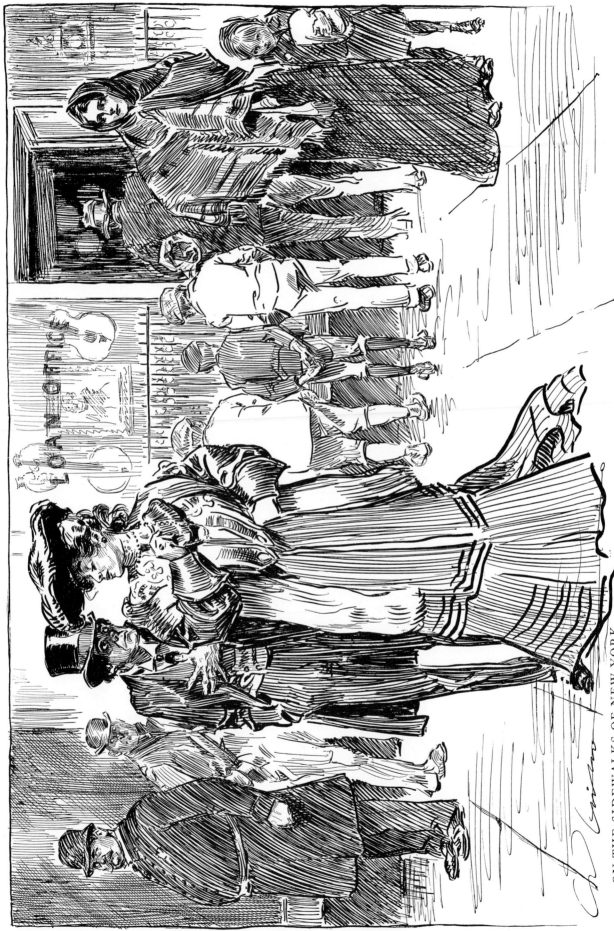

ON THE SIDEWALKS OF NEW YORK
Sequel to an unprofitable theatrical season.

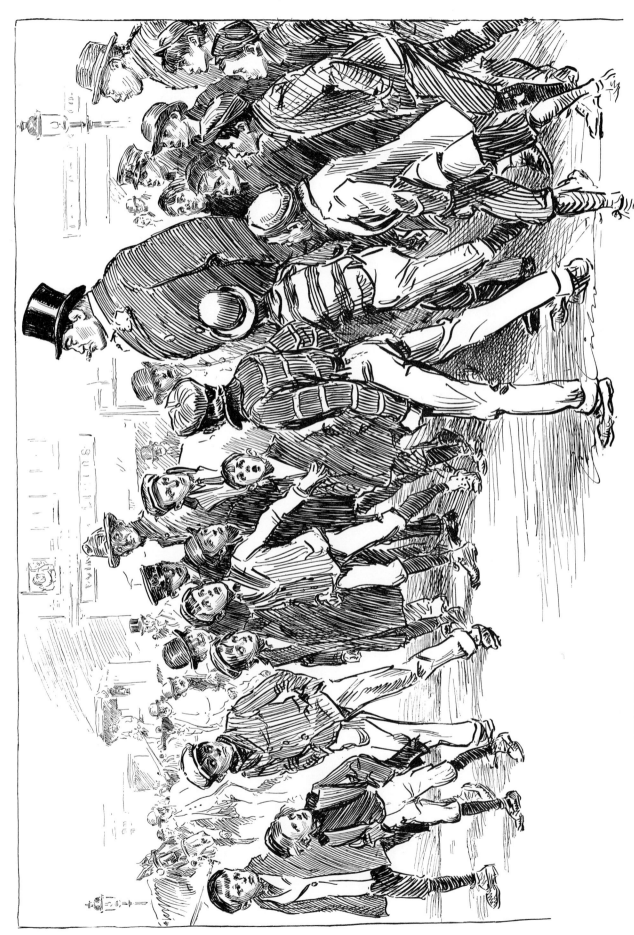

THE CHAMPION

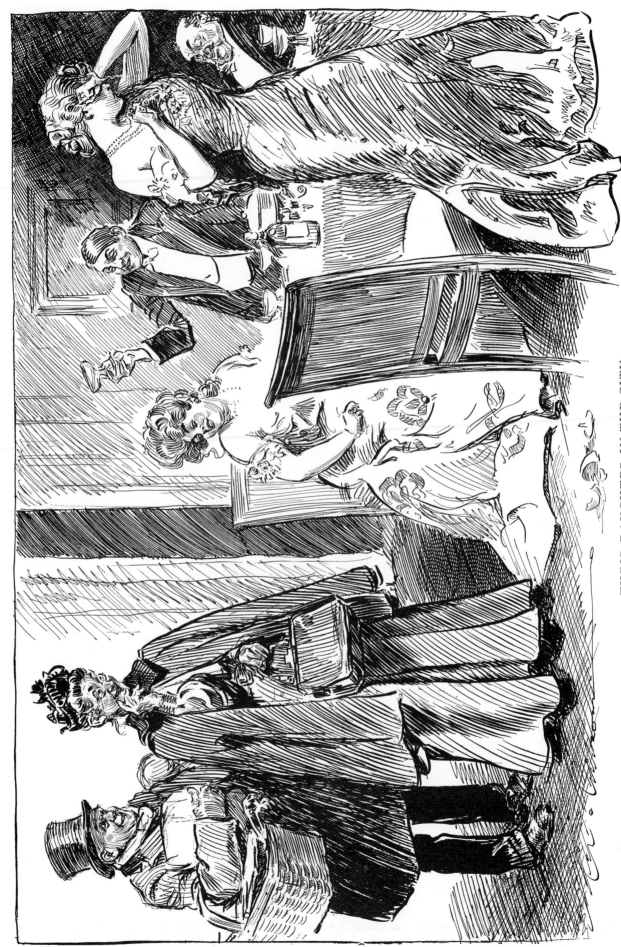

THEIR DAUGHTER IN THE CITY

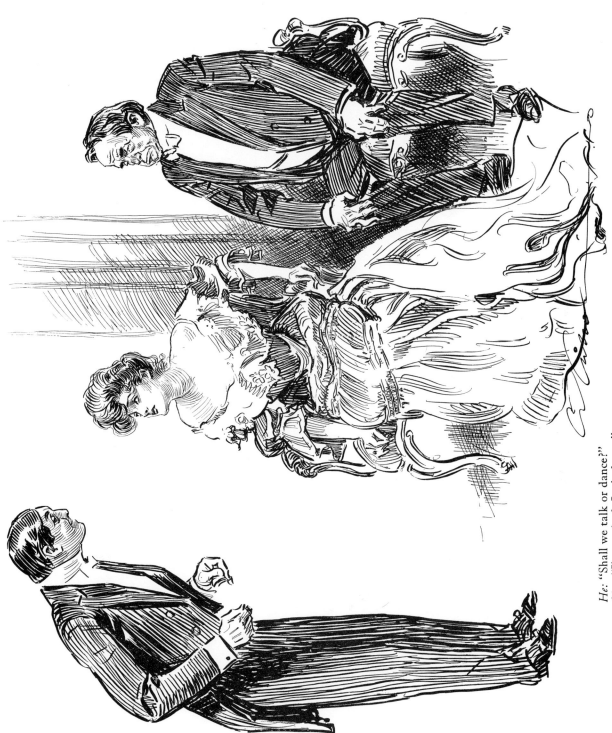

He: "Shall we talk or dance?"
She: "I'm so tired. Let's dance."

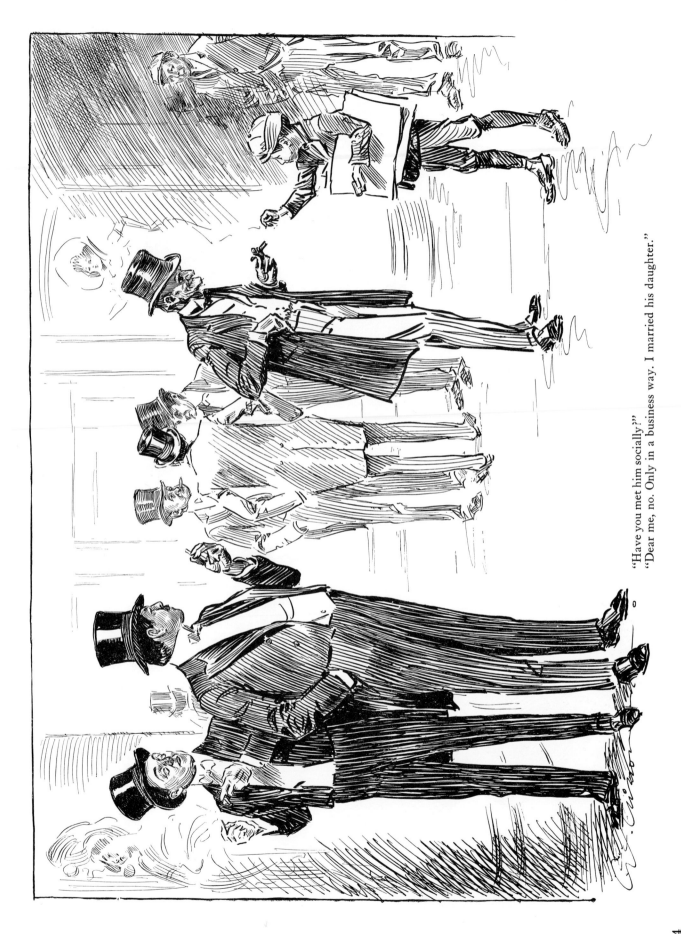

"Have you met him socially?"

"Dear me, no. Only in a business way. I married his daughter."

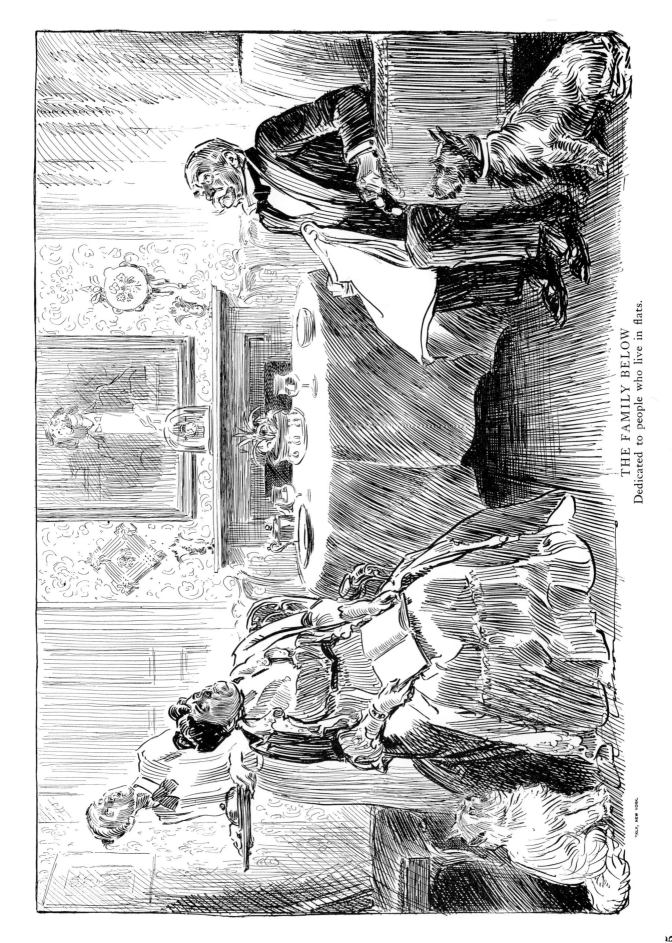

THE FAMILY BELOW
Dedicated to people who live in flats.

"KLY, NEW YORK.

125

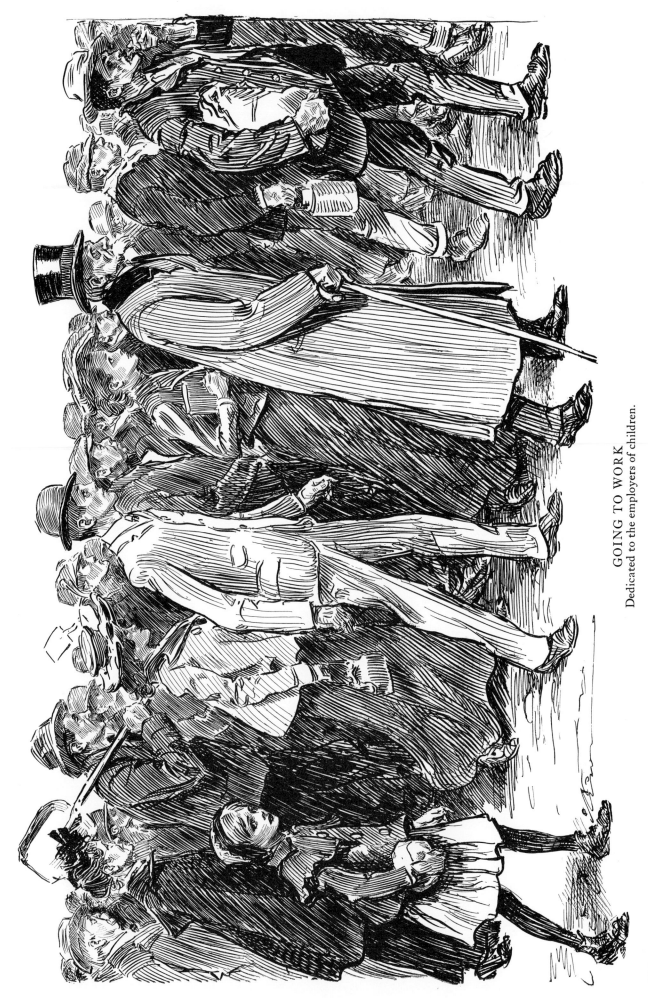

GOING TO WORK
Dedicated to the employers of children.

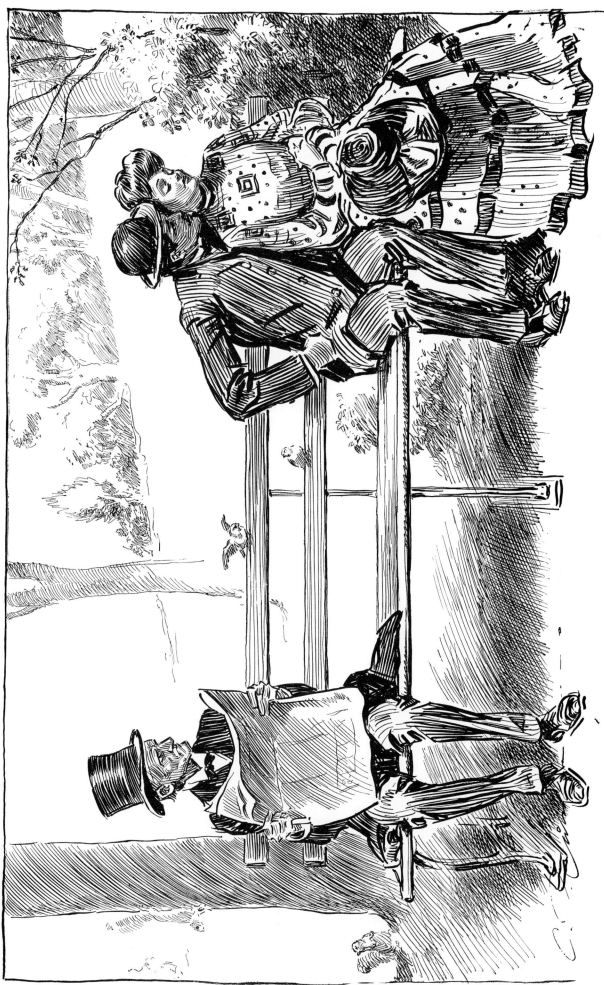

SIGNS OF SPRING

THE VILLAIN DIES

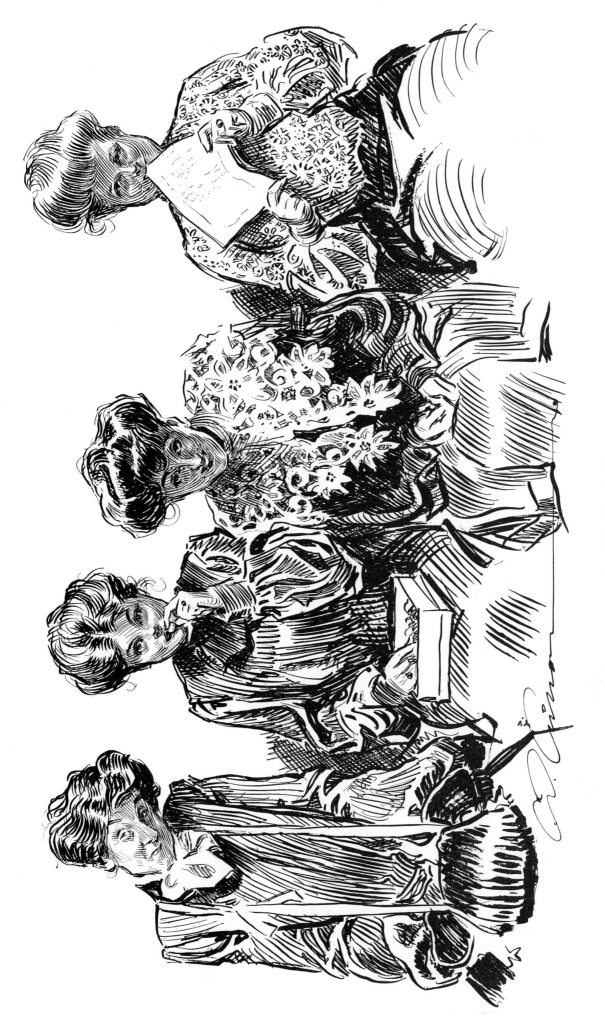

AT THE MATINEE

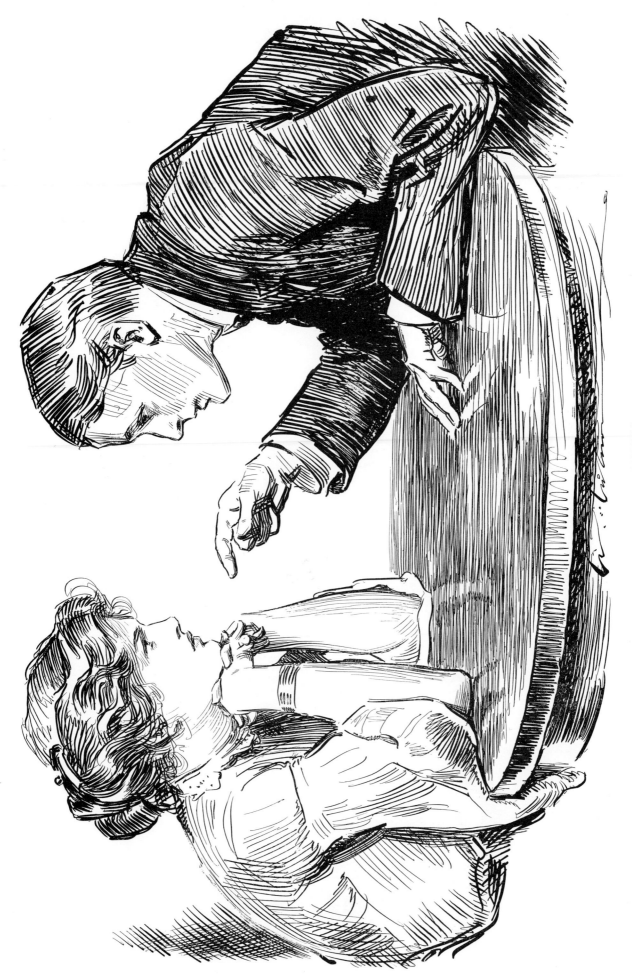

SERIOUS BUSINESS
A Young Lawyer Arguing his First Important Case.

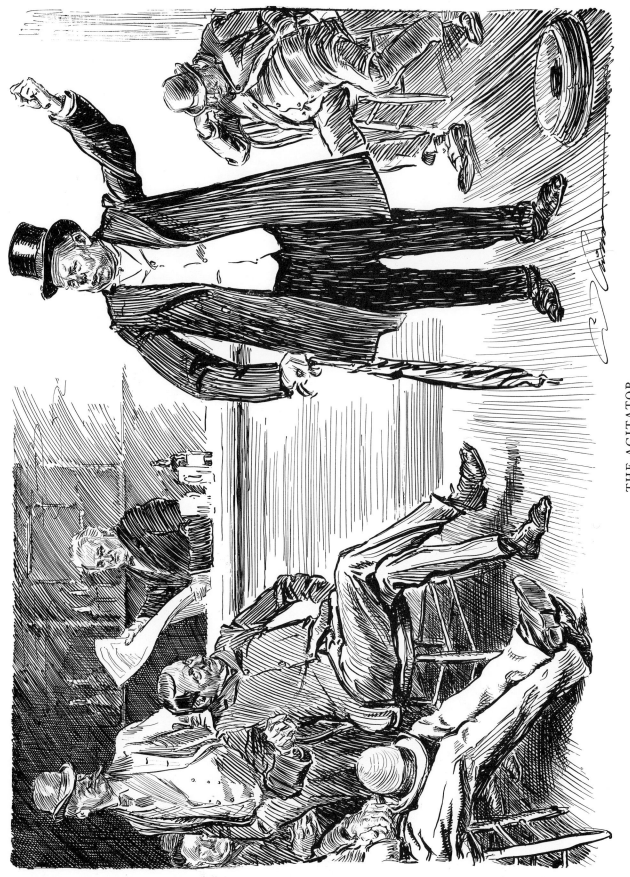

THE AGITATOR

"Who is it's brought us here, I ask you? Who's a-grindin' us under the iron heel o' despotism?
I say to you the time has come, when—"

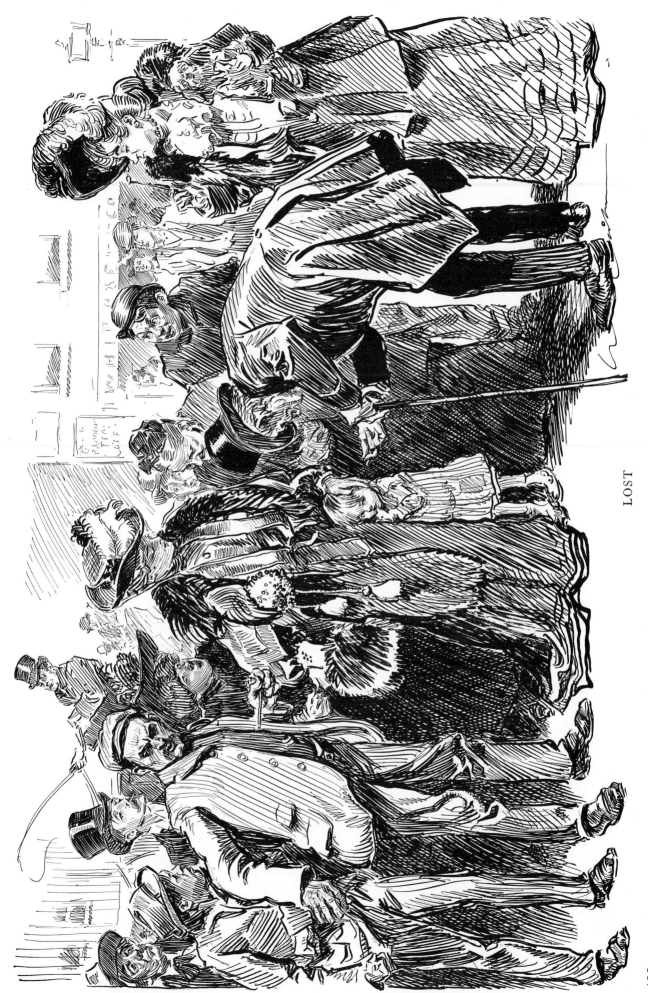

LOST

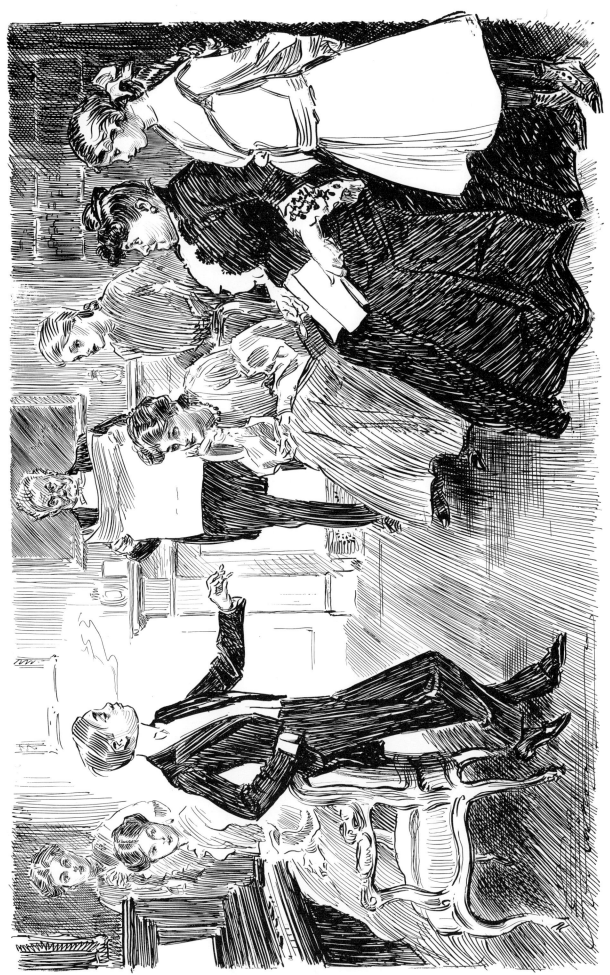

HOME FOR THE HOLIDAYS

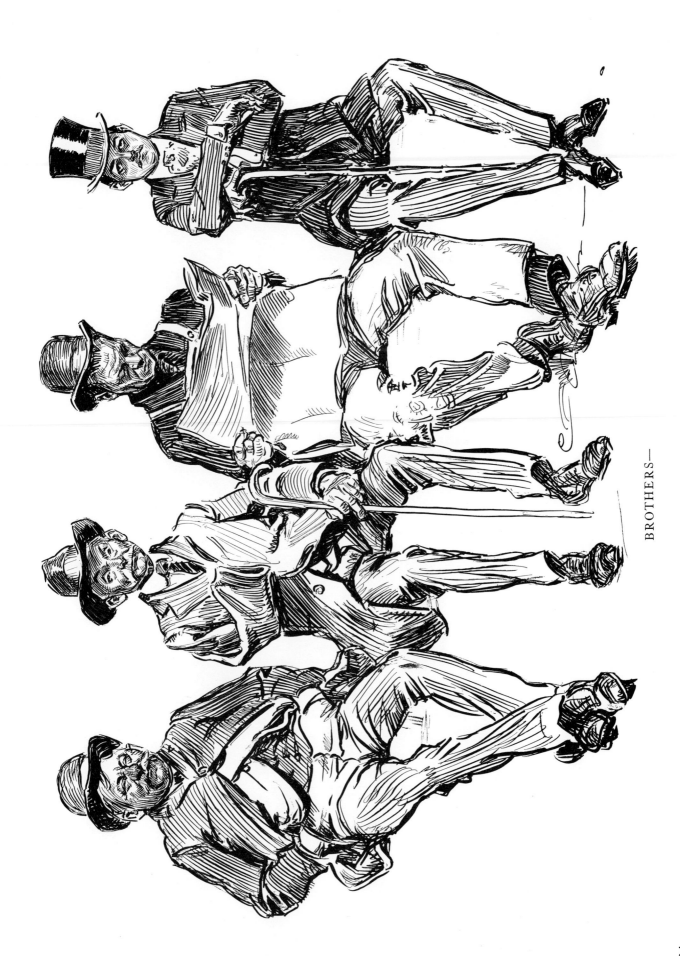

BROTHERS—

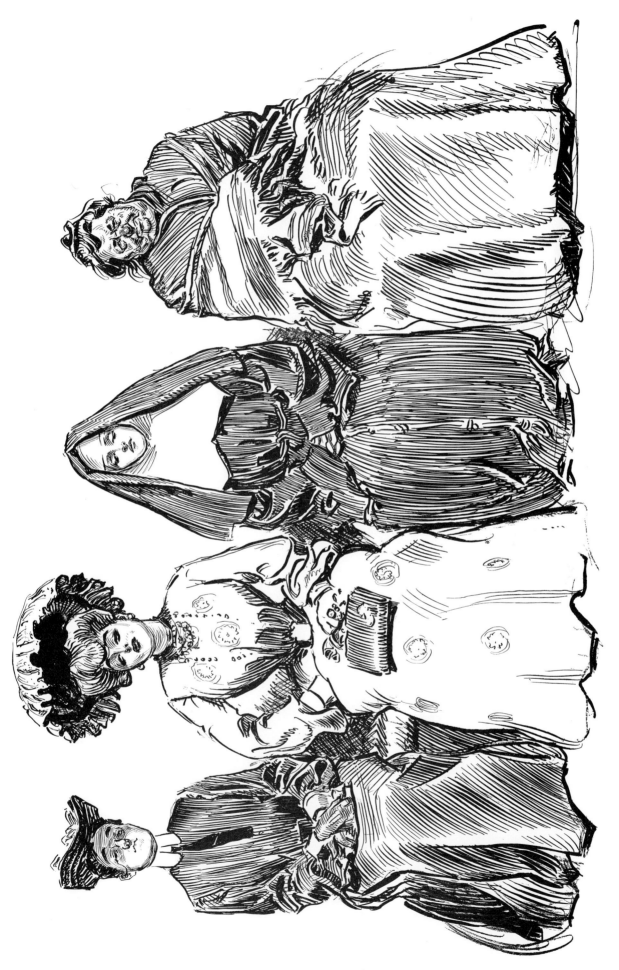

—AND—SISTERS

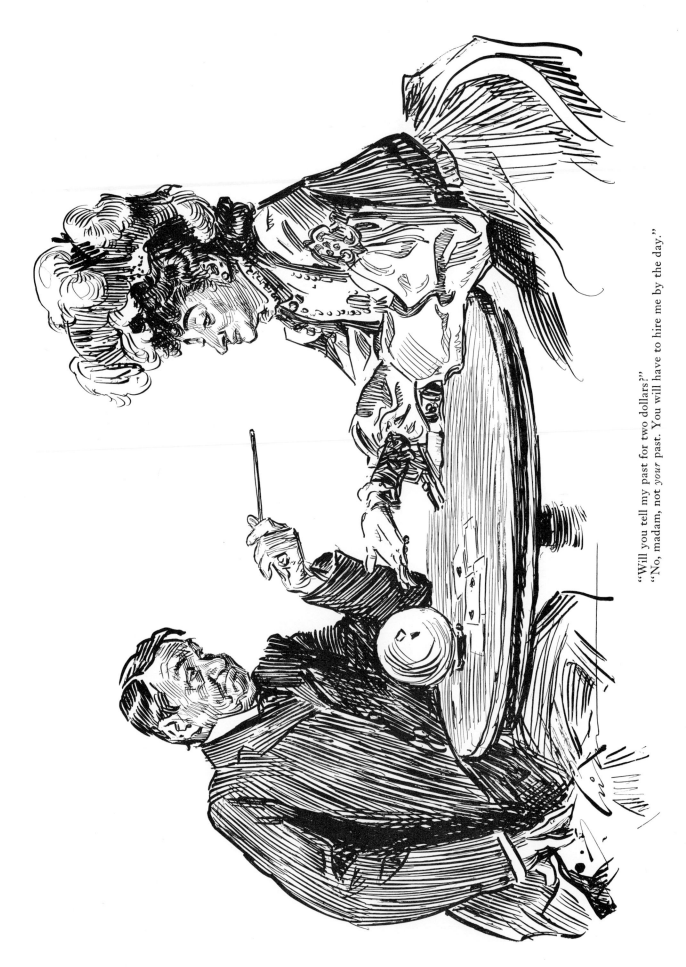

"Will you tell my past for two dollars?"
"No, madam, not *your* past. You will have to hire me by the day."

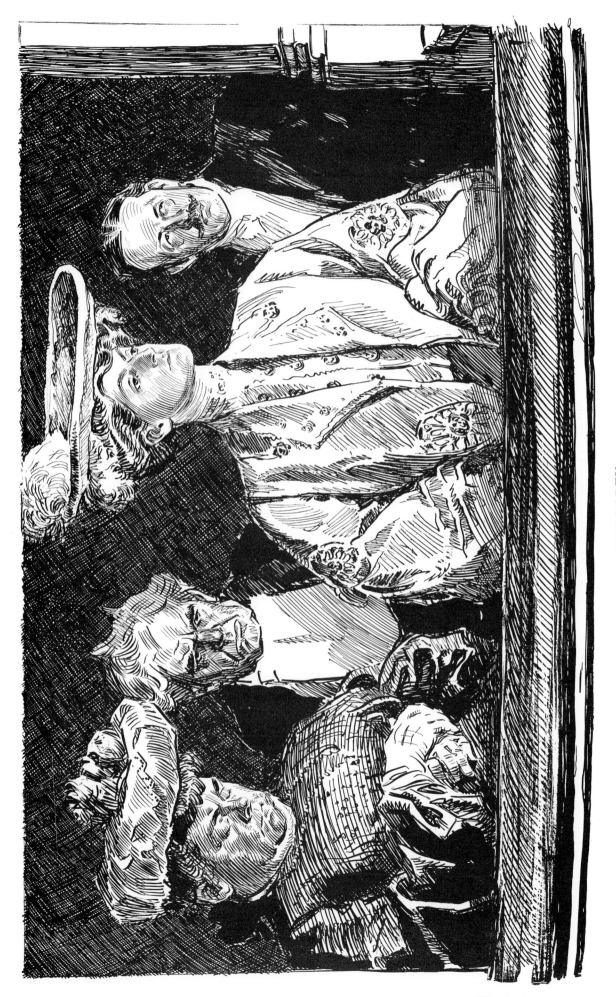

A BOX PARTY

OPENING OF THE RACING SEASON

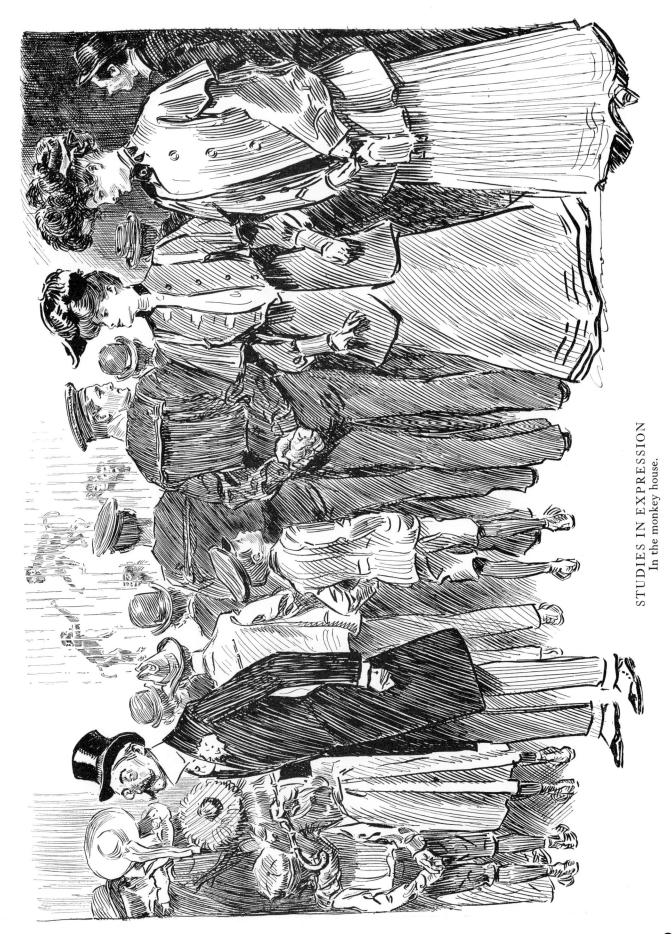

STUDIES IN EXPRESSION
In the monkey house.

SEEING NEW YORK (THE FLATIRON)

AT THE HORSE SHOW (THE HIGH JUMP)

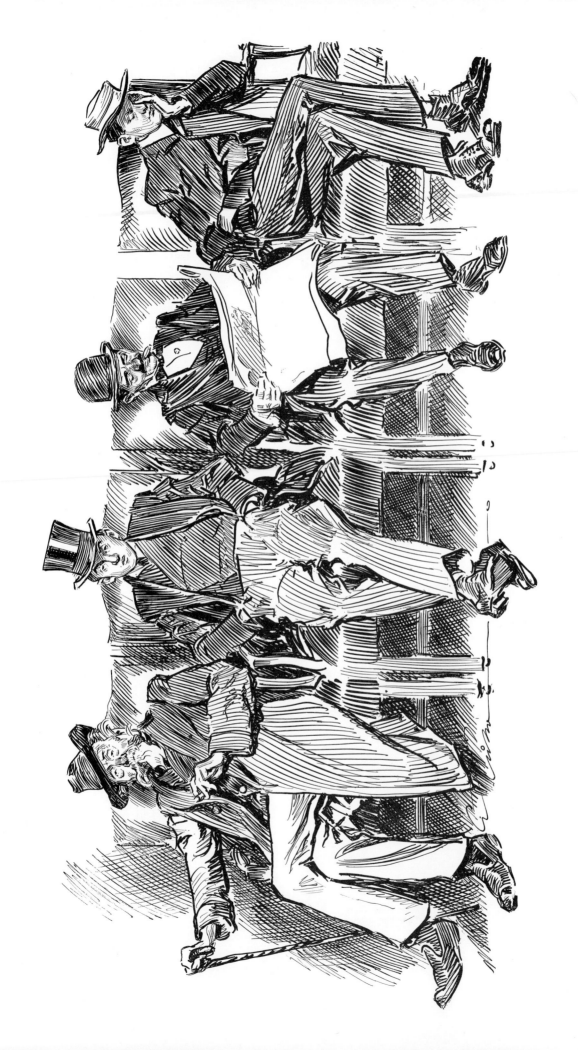

WAITING FOR SOMETHING TO TURN UP
(Scene in any hotel corridor)

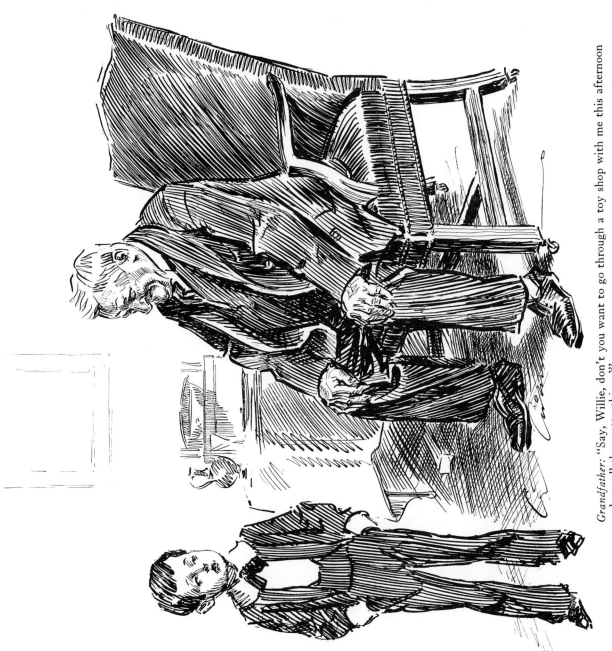

Grandfather: "Say, Willie, don't you want to go through a toy shop with me this afternoon and see all the pretty things?"
Willie: "I'm willing to, pop, if you will get any pleasure out of it."

143

MAKING UP HIS—?